West Highland White

Terrier

AN OWNER'S GUIDE

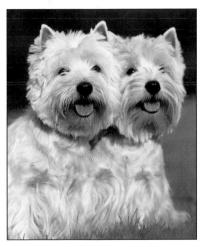

The authors

Robert Killick is a prominent breeder and exhibitor of Welsh Terriers, winning at the major Championship shows. He has a Judges Diploma (Credit) and judges all breeds at Open Show level and his own breed at Championship level.

After a lifetime in the theatre as a stage manager, director and actor, he turned to freelance journalism. In 1990, he became a weekly columnist for the UK canine newspaper *Our Dogs*. He also writes monthly columns in *Dogworld USA*, the world's largest circulating dog magazine, and the Swedish magazine *Hundesport*, and is a feature writer for *Dogs Today* in the UK.

In 1994, his poems were published by the American National Library of

Poetry for which he received the award of 'Poet of Merit' from the International Society of Poets, and he was nominated for 'Poet of the Year' in 1995.

John Bower BVSc, MRCVS is a senior partner in a small animal Veterinary Hospital in Plymouth, England. He has served as President of both the British Veterinary Association and the British Small Animal Veterinary Association. He writes regularly for the veterinary press and also for dog and cat publications. He is co-author of two dog healthcare books and a member of the Kennel Club.

Caroline Bower BVMS, MRCVS runs a veterinary health centre in the same practice as John. Her special interests include prevention and treatment of behavioural problems, and she lectures to dog breeding and training groups.

West Highland White
Terrier

AN OWNER'S GUIDE

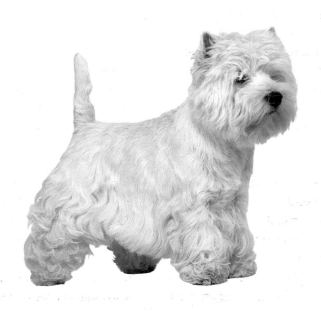

Robert Killick

DEDICATION
To my wife Jo, for your birthday, without your help there'd be no dogs.
Without them and you there'd be no career.

First published in 1996 by
Collins, an imprint of
HarperCollins*Publishers*
77-85 Fulham Palace Road
Hammersmith, London W6 8JB

The Collins website address is www.collins.co.uk

Collins is a registered trademark of HarperCollins Publishers Ltd

First published in paperback in 1999

This edition first published in 2003

09 08 07 06 05 04 03
9 8 7 6 5 4 3 2 1

© HarperCollins*Publishers* Ltd 1996
© Photographs: François Nicaise and HarperCollins*Publishers* Ltd 1996

Robert Killick asserts the moral right to be identified as the author of this work.

A catalogue record of this book is available from the British Library

ISBN 0 00 717831 X

This book was created by SP Creative Design for HarperCollins*Publishers* Ltd
Editor: Heather Thomas
Designers: Al Rockall and Rolando Ugolini
Production: Diane Clouting

Photography:
François Nicaise: Cover and pages 1, 3, 5, 6-7, 9 10, 13, 17, 18, 20, 23, 27, 28, 29-30, 32, 33, 34, 44, 45, 46, 52, 53, 54, 58, 62, 64, 65, 66, 68, 71, 73, 75, 77, 78, 79, 80, 81, 82, 83, 84, 85, 86, 87, 90, 91, 92, 94-95
David Dalton: Back cover and pages 14-15, 21, 36, 39, 41, 42, 43, 47, 48, 49, 50, 51, 55, 56, 59, 60, 61, 69, 88, 89
Frank Lane Picture Library: page 24

Acknowledgements
The publishers would like to thank the following for their kind assistance in producing this book: Scampers School for Dogs for their help with photography, and special thanks to Charlie Clarricoates for all his hard work; Sue Hawes of Soham Kennels (Haweswalton Westies) and Champion Haweswalton Apache (pages 14-15) and Haweswalton Soldier Soldier; Mrs Short and Misty; Mr D.J. and Mrs J.A. Griffiths and their Karamynd West Highland White Terriers

Colour reproduction by Colourscan, Singapore
Printed and bound by Printing Express Ltd, Hong Kong

CONTENTS

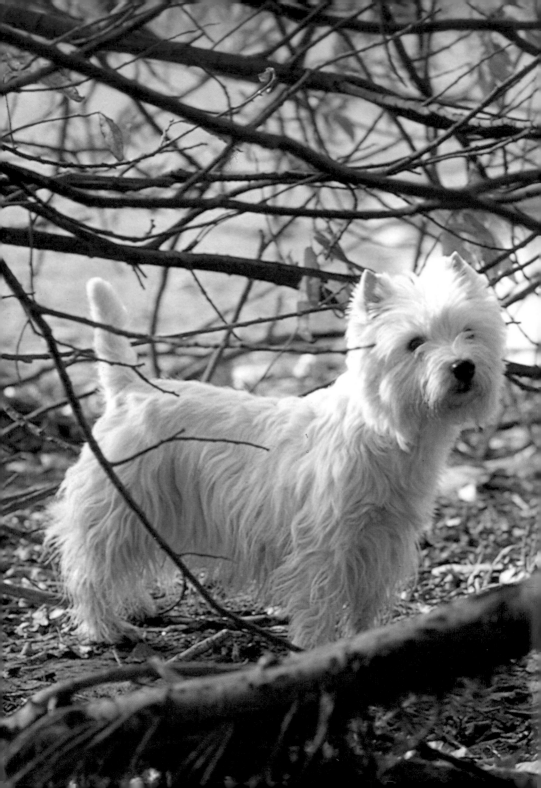

PART ONE

YOU AND YOUR DOG

The West Highland White Terrier, affectionately
known as a Westie, has not always been the same as
he appears today. Looking at this dark-eyed, little
fun-loving dog, it is hard to imagine that until about
100 years ago he was a scruffy, nondescript yard dog
killing vermin and defending the peasant crofts in
Scotland. What led to today's smart Cruft's winning
dog is surely a tribute to the breeders of those far-off
days, for it was they who spotted the West Highland
White Terrier's potential and it was their expertise
in breeding livestock that laid the foundations for
this game little dog with whom we are now so
familiar and who is one of the world's most
popular terrier breeds. Westies make ideal family
pets – loving and loyal with a streak of
independence, like all terriers.

THE HISTORY OF THE BREED

UNDERGROUND DOGS

Small fierce terrier-type dogs have frequented the British Isles since before recorded history. In the past, they were kept around homesteads to combat rats and other animals, such as foxes, which preyed on the villagers' poultry and lambs.

How terriers came into being is an enigma which may never be explained. The name comes from the Latin word 'terra', meaning earth, and refers to dogs that would go underground in pursuit of their prey. Anyone owning a terrier will agree that it is difficult to prevent them exploring any hole in the ground even if they have never seen one before.

Hunting dogs

Many woodcuts and prints from mediaeval times depict men hunting foxes and badgers with terriers to drive the animals from their lairs. In this enlightened age, baiting badgers is prohibited under the law and the hunting of foxes is a dying activity, but in order to understand the development of the breed it is essential to know of its bloody past and what was expected of the ancestors of today's Westie. The behaviour and characteristics of your pet or showdog are linked inextricably with its function at the beginning of its development, i.e. the terrier's implacable hatred of rats and foxes which was bred for by selection. Good hunters were bred from good hunting dogs and the best kept for work. Indeed, so well were these characteristics fixed that the majority of terriers still instinctively have this hatred of rats and other vermin to a greater or lesser degree to this day.

It is of immense significance that the British Isles is the only part of the world that has produced terriers. Every terrier breed derives from Britain and Ireland, and although nobody is certain how they were developed, the fact is that for hundreds of years local terriers of different types were bred all over these islands resulting in the twenty-five terrier breeds recognised throughout the world today.

Early days

The Phoenicians were influential in exporting dogs throughout Europe.

This typical dog is 'in the rough' and in need of the groomer's attention. Westies evolved from the yard dogs of nineteenth century Scottish crofters.

They were the first great wandering traders, sailing the known world 3,000 years ago, and clinging to the Mediterranean and Atlantic coasts. The dogs travelling on their ships might sometimes have escaped or were traded; ships were lost at sea occasionally, and they must have scrambled ashore after shipwrecks bringing new blood to the local canine population.

The rampaging Celts and other tribes that invaded Britain brought their own dogs as did the Vikings when they colonized great areas of the islands. World conquerors, like the Romans, also brought dogs with them, often collected from conquered countries. And when the Normans invaded in 1066, they brought their native hunting hound, the Talbot, in such numbers that it had a great influence on the indigenous breeds. There is no reason to suppose that they did not introduce other breeds from Europe during their conquest of Britain.

THE HIGHLAND TERRIER

From this amalgam of different breeds mixing with the native British dogs definite types emerged. In Scotland, the ubiquitous small terrier was a brown, short-legged dog with a rough, wiry coat, not unlike the modern Cairn, which at the time was known as the Highland Terrier. This dog was the fore runner of all the national Scottish terrier breeds.

The early 1800s was perhaps the beginning of a more general awareness of terriers; the various Hounds, Gun dogs and Toy dogs had been recognised as separate breeds for centuries, probably because of the interest of wealthy aristocrats in hunting and shooting and that of their ladies-in-companion's Toy dogs. Terriers may have been overlooked because they were the dogs of the peasants and working classes, nondescript

Westies are always ready for a game.

THE WEST HIGHLAND WHITE TERRIER CLUB

Luckily for us, there were some influential people who preferred white terriers, and prominent among these was the Malcolm family which, for three generations, probably beginning in the late 1700s, developed the breed we now recognise as the Westie from white or sandy-coloured Cairn types and the Highland Terrier. Sealyhams might have been introduced but produced dogs that were too long in the body. A vestige of white would have been the inheritance.

Colonel Edward Malcolm is credited with being the main founder of the West Highland White Terrier as a breed, and originally the dogs were called Poltalloch Terriers after the place in which he lived. In 1905, the White West Highland Club was formed with the venerable Colonel Malcolm as its first chairman, and in 1906, the Kennel Club, in granting the club registration, offered the name The West Highland White Terrier Club, while granting a southern club the name The West Highland White Terrier Club of England.

The formal creation of a club and the acceptance of registrations by the Kennel Club provided the stimulation for the improvements in conformation and beauty in the breed. West Highland White Terriers are now widespread throughout Europe and the United States, and have become one of our favourite dogs.

curs receiving scant attention for their work, often cruelly neglected and having to fend for themselves.

Development of the breed

The Highland Terrier, or early Cairn, came in several shades of colour, from a rich brown to a light wheaten verging on white. The lighter-coloured dogs were not very popular because they were perceived as less game than the darker ones. Added to this was the difficulty in seeing the dogs in the snow when hunting. At the time, gameness was of ultimate importance and the dog's appearance was of no consequence (except for the white colour). Generally, if dogs weren't good workers, they were not allowed to live. Paradoxically, the white ones were easier to see among the dark-coloured rocks when out hunting. Almost by accident, type began to be fixed and dogs began to look like each other within the breed. To some extent, this came about because of the lack of proper roads and transport. Owners of bitches could not travel far for a stud dog so they sought out suitable dogs locally, which meant close breeding, with the subsequent fixing of type. A definition of pedigree dogs is that they breed true in as much as any puppies produced by a dog and a bitch of the same breed resemble their parents.

THE BREED STANDARD

The Standard is a written and detailed description of an ideal dog compiled by the Kennel Club of Great Britain. It should not be considered as a blueprint because one dog can never be the same as another; it should be regarded as a guide to perfection.

We know that perfection does not exist which is why we strive to breed better dogs as close to the Standard as possible. The wording is often vague, and this can be to the breed's advantage because it allows for degrees of flexibility.

Anyone who seeks to buy puppies for exhibition or to breed them should immerse themselves in the breed and must make a study of the Standard to familiarize themselves with its every nuance.

A real insight into a breed is not gained overnight, nor does it matter how much theoretical knowledge is acquired. This is one activity that demands 'hands on' experience allied with the use of the brain. The thinking person will handle as many dogs as possible, will examine them, will groom them and, slowly, will

acquire an in-depth knowledge. If that same person brings the tiny pups into the world, rears them, studies their development into adulthood, lives close to them and then, at the end, buries them after a full life, he will be the person who knows the breed.

Type

A word most frequently used in relation to breeds of dogs, type is another concept which some people find difficulty in understanding. It should be considered in connection with the Standard. We all know the meaning of the word 'type' as used in normal conversation, but in the context of dogs the same word can have an entirely different meaning. The expression 'lacking in breed type' means that a dog lacks some of the qualities that make up that breed. In this context, 'type' means the hundreds of points that, when put together, make one breed distinguishable from all others. It is the opinion of many leading authorities that 'type' is contained within the Standard.

It is the breeder/exhibitor who seeks perfection. The exhibitor hopes to buy perfection whereas the pet owners, whose numbers far exceed the former, love their dogs as they are, but often they would still like to know if the possibility exists that they could win the big prize at Cruft's. By reading about the ideal West Highland White, the pet owner might like to try his hand at showing. The Breed Standard is reproduced by kind permission of the Kennel Club.

THE BREED STANDARD (continued overleaf)

General Appearance Strongly built; deep in chest and back ribs; level back and powerful quarters on muscular legs and exhibiting in a marked degree a great combination of strength and activity.

Characteristics Small, active, game, hardy, possessed of no small amount of self-esteem with a varminty appearance.

Temperament Alert, gay, courageous, self-reliant but friendly.

Gait/Movement Free, straight and easy all round. In front legs freely extended forward from shoulder. Hind movement free, strong and close. Stifle and hocks well flexed and hocks drawn under body giving drive. Stiff, stilted movement behind and cowhocks highly undesirable.

Colour White.

Size Height at withers approximately 28 cms (11 ins).

Faults Any departure from the foregoing points should be considered a fault and the seriousness with which the fault should be regarded should be in exact proportion to its degree.

Note: Male animals should have two apparently normal testicles fully descended into the scrotum.

THE BREED STANDARD

Reproduced by kind permission of the Kennel Club

Tail

12.5-15 cms (5-6 ins) long, covered with harsh hair, no feathering, as straight as possible, carried jauntily, not gay or carried over back. A long tail undesirable, and on no account should tails be docked.

Body

Compact. Back level, loins broad and strong. Chest deep and ribs well arched in upper half presenting a flattish side appearance. Back ribs of considerable depth and distance from last rib of quarters as short as compatible with free movement of body.

Hindquarters

Strong, muscular and wide across top. Legs short, muscular and sinewy. Thighs very muscular and not too wide apart. Hocks bent and well set in under body so as to be fairly close to each other when standing or moving. Straight or weak hocks most undesirable.

Coat

Double coated. Outer coat consists of harsh hair, about 5cms (2 ins) long, free from any curl. Undercoat, which resembles fur, short, soft and close. Open coats most undesirable.

Feet

Forefeet larger than hind, round, proportionate in size, strong, thickly padded and covered with short harsh hair.
Hindfeet are smaller and thickly padded. Under surface of pads and all nails preferably black.

Neck

Sufficiently long to allow proper set on of head required, muscular and gradually thickening towards base allowing neck to merge into nicely sloping shoulders.

Published by kind permission
of the Kennel Club

Ears

Small, erect and carried firmly, terminating in sharp point,
set neither too wide nor too close. Hair short and smooth
(velvety), should not be cut. Free from any fringe at top.
Round-pointed, broad, large or thick ears or too heavily
coated with hair most undesirable.

Eyes

Set wide apart, medium in size, not full, as dark as
possible. Slightly sunk in head, sharp and
intelligent, which, looking from under heavy
eyebrows, impart a piercing look. Light coloured
eyes highly undesirable.

Mouth

As broad between canine teeth as is consistent with
varminty expression required. Teeth large for size of
dog with regular scissor bite, i.e. upper teeth closely
overlapping lower teeth and set square to the jaws.

Head and Skull

Skull slightly domed; when
handled across forehead presents a
smooth contour. Tapering very
slightly from skull at level of ears to
eyes. Distance from occiput to eyes
slightly greater than length of
foreface. Head thickly coated with hair,
and carried at right angle or less, to
axis of neck. Head not to be carried in
extended position. Foreface gradually
tapering from eye to muzzle.

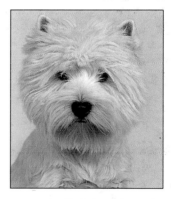

Distinct stop formed by heavy, bony ridges immediately above and
slightly overhanging eye, and slight indentation between eyes. Foreface
not dished nor falling away quickly below eyes, where it is well made up.
Jaws strong and level. Nose black and fairly large, forming smooth
contour with rest of muzzle. Nose not projecting forward.

Forequarters

Shoulders sloping backwards. Shoulder blades broad and lying close
to chest wall. Shoulder joint placed forward, elbows well in, allowing
foreleg to move freely, parallel to axis of body. Forelegs short and
muscular, straight and thickly covered with short, hard hair.

AN EXTENDED STANDARD

The Standard appears to be very comprehensive, but close examination reveals the use of words varying in meaning which permit really vast differences in interpretation, e.g. in the description of the head the word 'slightly' is used four times. It will mean different things to different people, but what is certain is that if there were fixed guidelines only one dog would win.

Another flexible point concerns measurements with no points of reference, e.g. 'Distance from occiput to eyes slightly greater than length of foreface'. Where do you start and finish: the front, middle or back of the occiput? There is 1.25 cm ($1/2$ in) difference. Measure to the eyes it tells us, but which part: the outside, the inside or the middle? The Standard does not call for exaggeration, the original function must always be considered, and balance and symmetry are essential.

Head

■ Because of the hairy presentation of the show dog it is not easy to assess the head. The shape of the skull is of paramount importance. A slightly domed skull is called for; a heavily domed head or an apple head will cause the ears and eyes to be wrongly placed.

■ The stop is an important feature in determining expression. It is the point where the front of the head drops to meet the top of the muzzle between the eyes. It should be a slope but never a vertical or near vertical step like a Pointer's, nor should it be shallow like that of a Collie.

■ The proportions of the skull to the muzzle are worth considering. The dog must have a strong jaw to do his job; over-long and it becomes snipy and weak; too short and the teeth get cramped.

■ A fairly substantial nose is the requirement. Westies use their fine scenting abilities more than is generally thought when hunting.

Eyes

■ Strangely enough, no eye colour is asked for, and the requirement is 'as dark as possible', a light-coloured eye being highly undesirable. The original Standard dated 1908 stipulates dark hazel eyes and condemns light-coloured ones.

■ The idea of a piercing look is hard to describe, but you will recognise it when you see it. The sharp and intelligent part of the description will fall into place too with experience.

Ears

■ These are an important aspect of the dog's expression. Small ears are asked

for – a relative term, small but in proportion to the head which they adorn, not too close together and not spread apart as on an exaggerated domed head. They should be pricked up as if the dog is ready for action.

West Highland White Terriers are very playful and fun-loving dogs.

Mouth

■ Teeth are vital for all dogs. They not only allow the animal to catch, kill and

eat their prey but they are also the sole means of defence. Therefore they must be properly placed and of the correct size. The British do not mind if one or two pre-molars (at the side of the mouth) are missing, but this is not the case in Europe and splendid dogs can be disqualified in some countries. This seems unfair considering that ancient skulls often show missing teeth, and there is evidence of wolves with missing teeth – evidence, perhaps, of an evolutionary process.

Neck

■ A good-length neck in proportion to the body is an essential. If the dog has well-laid shoulder blades, the neck should fit smoothly into the shoulders. The setting of the head on the end of the spinal column relates directly to the

section on the head, 'carried at right angle or less, to axis of neck'. The importance of the setting of the head on the neck cannot be stressed too much from an aesthetic point of view.

Body

■ The bones of the body are a chassis from which the moving parts hang and to which the muscles operating these moving parts are attached. It must be formed correctly and strong enough to bear the stresses. The backbone is the key: ribs should spring out from their connection to the backbone and flatten off at the sides; the chest should be deep, reaching at least to the elbow.

■ The words 'short back' allude to the loin: the join between the last rib and the thigh. This should be fairly short, giving great strength; short rib cages are wrong.

Gait/movement, fore and hind quarters

■ Any failure in these parts will reflect on the efficiency of the others. With the right vertebrae for the breed, correctly angled joints, correct positioning of the forehand and the pelvis allied with strong straight bones, the dog should produce the correct movement.

Coat and colour

■ The white colour is the mark of the breed. Sometimes there are light brown marks, which can be hereditary or due to diet. They can be regulated by judicious trimming. The coat must be harsh with a soft undercoat. A soft, wavy top coat is an abomination.

Size

■ There is always argument about size. The standard uses the word 'approximately' and thus a variation is permissible, but many experts still stick slavishly to 27.5 cm (11 in) at the withers. However, the old 1908 standard, which was prepared by people who understood hunting and the terrain over which these dogs worked, stated 20-30 cm (8-12 in). For the same reason, in those days the weight was also of importance, and this seems to have been forgotten in the re-writes of the Standard. In the dog showing world there is no gain from going against the flow, and a small male dog is unlikely to be considered for top awards, rightly or wrongly.

Varminty

■ This is the term used when discussing expression. 'Varmint' means a 'noxious or troublesome animal' but in the context of the Standard the dog must look as if it is ready to face its natural foes. It is a look of mischievous recklessness caused by a combination of the angle of the piercing eyes and the position of the ears in relation to the shape of the skull and muzzle.

THE SHOW DOG

In the ninety years since the West Highland White was first exhibited, hundreds of kennels have appeared. Many have become legends, whereas many others have disappeared virtually without trace. Thousands of dogs have been shown, some of whom, like their kennels, have made a lasting impression. It could be argued that the original kennels are the most significant because they set the pattern and the genetic structure that still influence the breed. Originally, the Cairn and the West Highlander were so intermingled that dogs from the same litter were shown as two different breeds according to their colour and it was not until 1924 that the Kennel Club stopped the mixing of the two breeds. History shows that one dog,

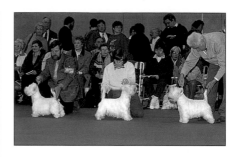

The formal atmosphere of the show ring.

Conus, dominated the early scene, and he was the grandfather of the first West Highland White champion, Ch. Morven, and the grandfather of the first Cairn champion, Ch. Gesto. However, his own grandfather was a Scottish Terrier and this explains why the occasional oddity happens in the best regulated kennels to this day. Conus sired several dogs of

RECENT DEVELOPMENTS

Breeding started again after the war. Mrs D. Mary Dennis's Branston kennels rose to fame in 1948, and she made twenty-five champions, the third largest number. As popularity increased, the breed began to win at a very high level: so many kennels made their mark with multiple CC winning dogs that records were made and broken annually. The Famecheck kennels, owned by Miss F.M.C. Cooke, took second place in the league, making thirty-seven English

champions. Professional handler Ernest Sharpe held the CC record with thirty-three, only to be beaten by the great Ch. Olac Moon Pilot with forty-eight CCs in the hands of his breeder, Derek Tattersall, whose skill in presentation is legendary. Moon Pilot is the second Westie to win the greatest accolade of the Supreme Champion at Cruft's. The first was in 1976 when Geoff Corish, a young professional handler, took Ch. Dianthus Buttons to the top spot.

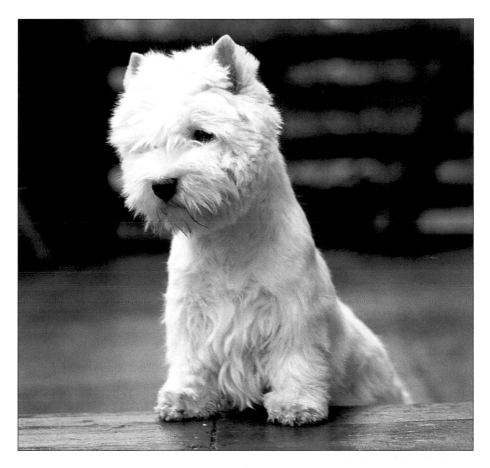

In a relaxed mood, Champion Olac Moon Pilot, Cruft's Best in Show 1990 (bred by Mr and Mrs D & J Tattersall).

significance, including the bitch Ch. Runag who was much praised by the cognoscenti of the time. The breed continued to gain popularity, achieving 3,947 registrations by 1916 when a very important kennel came into prominence. May Pacey, under her 'Wolvey' prefix, was responsible for fifty-eight champions, forty of which were home bred. The onset of World War I in Europe heralded a cessation of dog shows, and large kennels were forced to close or severely curtail their activities due to lack of food but with the restoration of peace the breed recovered quickly. Many kennels rose to eminence and 125 champions were made between 1920 and the outbreak of World War II.

ORIGINS AND BEHAVIOUR

THE EVOLUTION OF DOGS

The origins and evolution of dogs are subjects that have taxed the brains of canine historians for years. You might think that a great deal is known as dogs have been linked inextricably to humans since prehistoric times, but this is not so. It is often said that the close relationship between dog and man has developed over a period of 20,000 years, but concrete knowledge begins only in the last 1,000 years and detailed breed knowledge only since the eighteenth century.

Evidence of the evolution of dogs is sparse, as is evidence of how two such disparate species, humans and dogs, should come to be so dependent on each other. Flesh, tissue and hair rarely survive over millions of years, and up to now bones have revealed very little about how today's dogs evolved from the tree-dwelling animal that some experts believe to have been their ancestor.

Sixty million years ago

Prehistoric creatures must be examined against an incredibly hostile environment with few clues as to their origins. A strange looking animal, not unlike a polecat, known as Miacis, is credited as being the ancestor of dogs. From this creature came Cynodictus and eventually the prototype dog, the Tomarctus.

Thirty million years passed and the large wolf-like animals that were to be found all over the world disappeared to be replaced with smaller canids. Evolution continued inexorably and about seven million years ago the really significant divisions started to happen. It is thought that the land-dwelling animals slowly split into two great groups: the first containing dogs, raccoons, bears, weasels and otters; whereas in the second group were cats, civets, genets and hyenas. Improbably, it seems that there is a very remote relationship between dogs and cats!

The man/wolf/dog relationship

The next part of the story needs real imagination. How did a wolf/dog-type animal become friendly with man? Imagine that it is dusk; outside a cave a

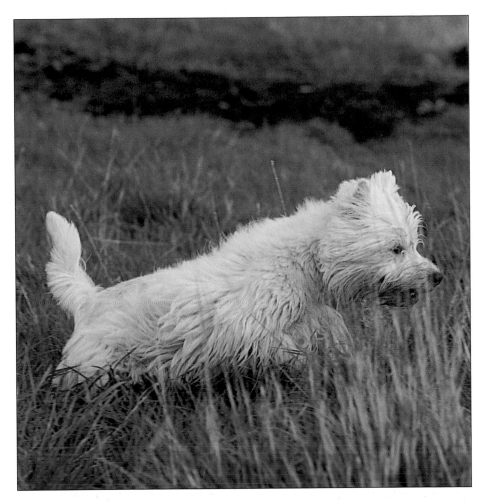

The West Highland White retains much of his hunting instincts.

prehistoric family crouches round a fire tearing at juicy mammoth steaks. They throw the bones over their shoulders, and glittering eyes in the bushes mark the fall of each bone. Later the family goes into the cave for the night and lurking wolf-like figures creep out and snatch up the bones. Contact has been made.

Wolves, with their superior intelligence, soon learned that man was a good source of food and would follow hunting parties as scavengers. Man, a creature of greater intelligence than other animals, quickly recognised the wolf's hunting skills, its speed over the terrain

and its alertness around the dwelling. Modern thought is that dogs evolved from wolves although it is conceded that there are several quite different types of wolf and they may have intermingled with the Dhole or Indian Red Dog types due to man's nomadic existence. The Cape Hunting Dog is also a strong contender in the 'origin of dogs' stakes.

Domestication of the wolf

Man, ever an opportunist, would have thought of the wolf creature as a walking meal. The children may have found puppies and taken them back to the cave to eat, only to discover that they were playful and warm to cuddle at night. Domestication would have begun when both creatures became used to one another. Hundreds of years, perhaps

thousands, would pass before early man began to keep animals and to slowly change to a pastoral existence. The wolf/dog would still have hunted but now man was discovering other facets of the animal which was now sharing his life.

Man and dog became so dependent upon each other that they both had an effect on the other's evolution. For instance, the mere fact that the dog guarded flocks and herds from predators would have made it easier for early man to develop. The fact that man provided regular food for the dog would change its development too. Scientists have

These young wolves are contesting for leadership. Wolves and wild dogs live in organised packs led by a dominant male or female.

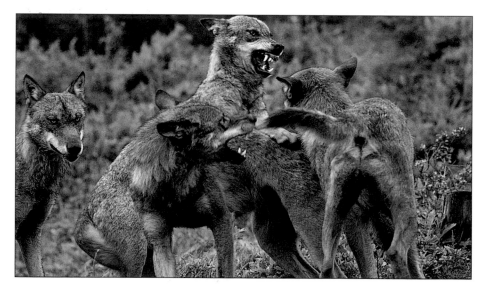

sufficient proof of the close proximity of the two species to satisfy themselves that dogs played an important role in primitive times.

Dogs in the wild

To understand your own pet it is as well to know something of the dog in the wild. By nature the dog is a pack animal, a characteristic inherited from its wolf ancestors – not vast numbers of animals living together but extended family groups. Wild dogs live within a clearly defined social pecking order with one dominant who can be either male or female. They are opportunists, not only killing their own prey with planned attacks but also scavenging for food left by other predators, their gastric juices allowing them to eat things that we would consider disgusting. Their habits of eating faeces and rolling in muck stem from behavioural traits inherited from the wild state.

Ancient Egypt

Hard evidence that dogs occupied a position of importance in early civilised society comes from ancient Egypt some 6,000 years ago. Mummified remains were found in the tombs of kings indicating that dogs were favourites of royalty. The god Anubis, half man and half dog, was believed to escort souls after death, and this is another indication of the high

EARLY DOGS

From early dogs came four distinct types: the basic herding sheepdog; hunting, hauling and toy dogs; sight hounds such as greyhounds and desert gaze hounds; and the big guarding mastiff-style dogs with some water dogs. This is only a rough guide but all breeds of dogs stem from very few types. The incredible diversity of the canine race in both size and function is largely, but not totally, derived from mankind's interference in the natural process of evolution.

esteem enjoyed by dogs. Depicted on urns and vases were recognisable gaze hounds such as Greyhounds, Salukis and the rare Azawaki. It comes as no surprise that hunting dogs were prominent, but short-legged dogs are also found in the drawings of the period and these may be the ancestors of Terriers.

In Europe

Evidence of the popular use of dogs comes from Roman statues, mosaics and burial grounds. Archaeological digs in burial mounds have uncovered bones of dogs alongside human remains. There is evidence of dogs from carvings on tombstones, from tapestries and in paintings but it was not until 1570 that the first attempt to categorize dogs in print came with Dr Caius's book, 'Of English Dogges'.

BEHAVIOURAL CHARACTERISTICS

The West Highland White Terrier is a dog that loves his family. It is his pack, but, like all Terriers, he has a streak of independence. After all, their original function was to perform some relatively dangerous tasks on their own initiative. He is not always an easy dog and can be obdurate and self-willed, often trying to impose his will on others and being generally difficult. However, he adores to be involved with family happenings and always wants to help, gardening being his speciality!

Good pets

Provided that he is trained, the Westie is an excellent choice for a pet. He fits into any household; he is sturdy and hardy; and he will take exercise until the owner falls over or he will be content with three walks a day round the park. Like most Terriers he understands children but they should be taught to respect him because he might object to harsh treatment (although with babies he can be very protective).

When he gets to about a year old, he will almost certainly challenge for the position of top dog unless he has been trained from an early age with firmness and kindness. By nature he is a happy dog: inquisitive, full of mischief and energy, always amusing, relatively easy to train and generally affable to other dogs, although he will most certainly stand his ground if confronted. Although he is not a noisy dog, his big bark is out of proportion to his size, and he will guard the home and warn of any visitors, welcome or otherwise. He loves to give the impression that he is a very superior canine but with humans he is a big softy!

Behaviour and training

Problem dogs are invariably the fault of their owners, and puppies, like children, have to be taught to behave. The real problems start if the puppy is not socialized from birth. As a general rule, kennel-bred dogs do not have the necessary early socialization. Even young puppies, whether they are pets or show dogs, need to be handled and spoken to, the more the better.

Dogs should not be treated as small hairy humans; they have their own special needs and it should be remembered that they have only a thin veneer of domestication. To live

Westies love to be involved in all aspects of family life, including gardening. However, their efforts may not always be appreciated!

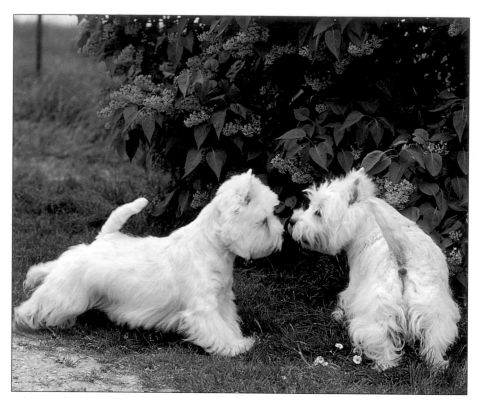

satisfactorily in the human condition they have to learn a language, the pattern of behaviour of a particular household and their position in the pack. Patient kindness, as with a young child, is the key to successful integration. You would not expect a child to be toilet-trained in a week, nor should a puppy be expected to be house-trained in a week.

Impose yourself

A dog is always happiest when he knows his position relative to that of other members of the family. At least one person

Westies are sociable by nature, and are generally affable towards other dogs although they will stand their ground if they are confronted.

should assume the role of pack leader and should control the dog, even if it is only basic training such as 'sit', 'lie down' and 'come'. These three commands will suffice even in the most difficult situations. The dog will respect whoever trains him provided that it is done quietly on the 'praise and reward system' with the use of the voice.

DANGEROUS DOGS

Neglect, harsh treatment and tormenting will make most dogs dangerous, including comparatively small ones. They all bite from fear and a lack of security. Unfortunately, not everyone loves dogs and there is an increasing anti-dog faction in society which delight in making life difficult for dog owners seizing any excuse to discredit both owners and dogs.

Attitudes towards dogs are changing and exaggerated media reports are designed deliberately to frighten people into the belief that dogs are serious disease carriers when the truth is that ordinary hygiene will control the small risks. It behoves every dog owner to train his dog to be socially acceptable, never allowing him to walk unaccompanied and always to keep him under complete control in public places. Above all, the owner should pick up any mess after his dog should he defecate in a public place. Most people find faeces repugnant and it is often the catalyst stimulating the hatred and fear of dogs.

Never hit a West Highland White; it is counter-productive and you will end up with either a cowed dog or a mutinous one. In either case, he will be unhappy because in nature he is never struck and it will be beyond his understanding.

Intelligence and senses

Dogs are intelligent animals, and they learn by short bursts of repetition – too much intensive training at one time and they become bored. Westies are bright and can easily think of something that is more interesting to do, such as playing, running and imaginary hunting but they respond well to training. Their senses are more acute than is often realised, and in the wild they survive by these alone. They are quick to discern moods and will soon learn to disappear if the family is quarrelling. Indeed they are so adapt at

reading body language that it is possible to believe that they possess a sixth sense. Their hearing is probably between ten and twenty times more acute than ours. If they prick up their ears and bark you can be sure that there is something or someone around. It may be the cat from next door and you won't hear it but your Westie will.

The dog's most remarkable sense, and this applies to every breed, is his incredible sense of smell; expert estimates vary from 1,000 to 1,000,000 times more powerful than humans. The Westie's hunting past means that his sense of smell is highly developed and he can actually differentiate between dozens of different scents. Indeed, if he puts his nose in a hole and wags his tail, you will know unfailingly that there is something down there.

CARING FOR YOUR DOG

Buying a dog is one of the most important decisions a family has to take. You will be responsible for a small, living creature for up to fifteen years, and a dog must never be regarded as an object to just buy, sell or give away as the mood dictates. A dog is always for life! Consider carefully if your lifestyle permits you to care for a puppy properly. For instance, if both husband and wife are out at work all day it would not be fair to introduce a puppy to the household. The dog might even develop behavioural problems in later life, e.g. being destructive and antisocial. A dog needs regular feeding, grooming, exercise and companionship, and you must be prepared to spend some time each day playing with him. You must also consider the cost of his food, veterinary bills and even insurance.

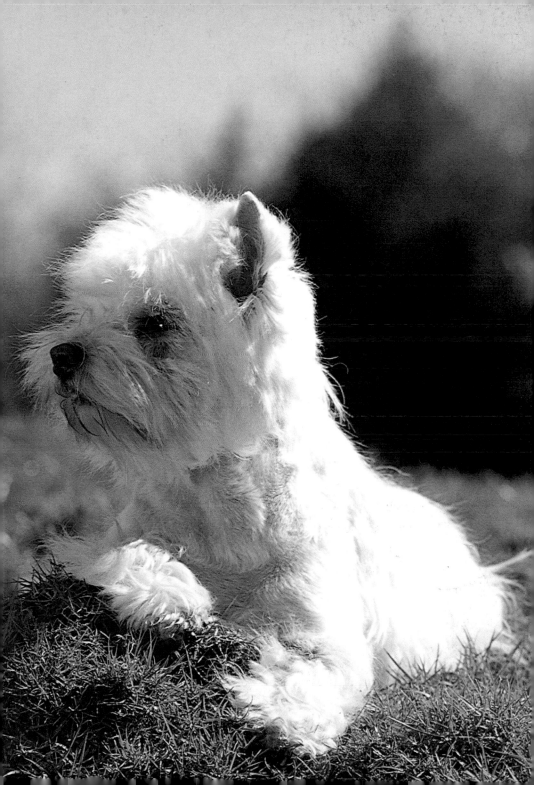

THE NEW PUPPY

FINDING A BREEDER

No puppy should be purchased on impulse, so don't buy from someone you meet in a bar, the pet shop or a dealer. None of these will be able to offer any after-sales help or advice. They will disassociate themselves after the sale because almost certainly the dog will not have been reared correctly and he may not even be strong enough to survive. At the best, he may require expensive veterinary treatment just to survive the first few vital weeks after leaving the nursery.

Because of their popularity, West Highland White Terriers are often bred by unscrupulous people out to make a quick buck, and you should avoid commercial breeders and puppy farmers. The likelihood is that they breed only for money and will not know or care about improving the breed nor understand the problems of inherited conditions. Always buy from a licensed breeder, one who specializes in West Highland White Terriers and is also a dog show exhibitor.

Try to find one who is approved by the Kennel Club or recommended by a charity, such as Pro-Dogs in the UK, which has a system of vetting breeders and recommends only those that meet the highest standards.

■ These breeders should have a 'buy back' guarantee in the unlikely event of the dog requiring re-homing. It can happen that circumstances of death, divorce or movement to a foreign country not permitting the entry of dogs results in a dog having to be re-homed. A guarantee effectively stops the dog falling into the wrong hands and perhaps being put down.

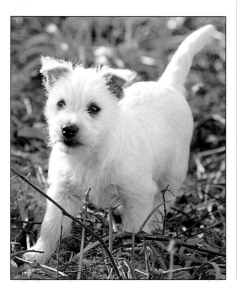

Puppies are naturally inquisitive and are always looking for mischief.

DO YOUR RESEARCH

Having made the decision, it is time to do some research and find out as much about the West Highland White Terrier as possible. The probability is that you will be looking for a puppy between the age of eight and ten weeks, so first you must decide which sex you want – each has its own merits. Ignore advice from non-experts; some advise that dogs are likely to wander and are not as faithful, whereas others claim that bitches are gentler. However, there's little difference: dogs are what you train them to be. Remember that bitches need

A proud mother with her litter of lovable little demons.

to be controlled when in season unless they have been spayed; it is anti-social to have unwanted litters.

Breeders who care

■ You will be looking for a breeder who cares, one who rears the puppies in the house and who will allow you to choose. The best breeders will include one month's insurance in the price of the pup or, at least, offer facilities or advice on insurance.

■ They should provide a diet sheet and a few days' supply of the food on which the little puppy has been reared. This will help to prevent any tummy upsets, as a young puppy's digestive system is likely to be sensitive. Prepare for his arrival

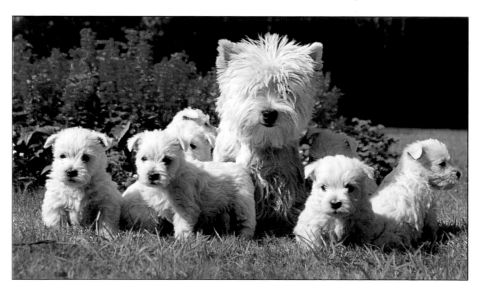

FINDING THE RIGHT BREEDER

- Telephone the Kennel Club and any relevant organizations, such as Pro-Dogs, for a list of breeders.
- Contact the secretary of one of the breed clubs.
- Speak to as many breeders as possible and tell them you want a good representative of the breed.
- Do not buy because a pup is cheap; you are not just buying a puppy, you are buying years of experience and knowledge – a heritage as long as your own.
- Find out when the breeders will be at a championship show within a reasonable distance of your home and arrange to meet.
- At the same time look closely at the dogs in the show ring, observing how the handlers treat their dog. You may have to travel a bit but be patient. When you find the right dog, the wait will have been worthwhile.

by buying in a small supply of the recommended food in advance, and if you decide to change it for any reason, do so gradually over a period of time by adding just a little of the new food to the original and slowly increasing the proportion of the new one.

- The puppy should have been wormed, and advice should be offered by the breeder for further treatment. If in doubt, consult your vet.
- Kennel Club registration documents and a pedigree should be handed over to you by the breeder on completion of the sale. Be prepared to answer a few forthright questions; the best breeders are very concerned that their puppies should go to responsible owners.
- At the breeder's home, ask to see the mother with her litter. Keep your children under control, sit quietly and watch the puppies, giving them time to settle – they may not have seen many strangers. The choice may be difficult, but it may be that one will show interest in you. In any event, look for a brave puppy who is full of himself. Make sure that he moves freely and, for preference, has black or nearly black pigmentation of the nose and eyelids, and bright, clean eyes with no discharges.

- Be suspicious if you are offered a pup who is cheaper than his litter-mates because there is something wrong with him. Take your time and don't be bulldozed into making a quick decision. If you are not completely happy, don't do it.

CHECKLIST

For your new puppy you will need:
- An escape-proof garden
- A sturdy bed
- Indestructible bedding
- Dog chews and toys
- Collar and lead
- Food and water bowls

PREPARING FOR THE NEW PUPPY

In his new home, the puppy should have a quiet corner allocated to him, with a sturdy box or hard, unchewable plastic bed with soft bedding. There are several almost indestructible, machine-washable, man-made fabrics readily available from pet shops. He needs a couple of strong toys, an artificial bone and hide chews to chew on. Like a child, he needs something to bite on whilst his permanent teeth are emerging. Everything should be unbreakable and large enough not to swallow.

An escape-proof garden

■ This is a necessity as terriers can get through surprisingly small holes. A wire mesh fence, about 1.5 m/5 ft high, would be sufficient, with gates that do not stay open if visiting tradesmen forget to close them. Generally, Westies don't have much sense of traffic, and if they run on the road the chances are that they will be run over. It's not that they want to escape but they do have an insatiable curiosity. They don't realise that the neighbours will not appreciate a small terrier rampaging over their flower beds.

■ Dogs don't know the difference between flowers and weeds, so don't be surprised if your Westie brings your own geraniums to you because he thinks he's doing you a favour.

Indoor pens and chew-proof beds are useful for keeping puppies under control for short periods.

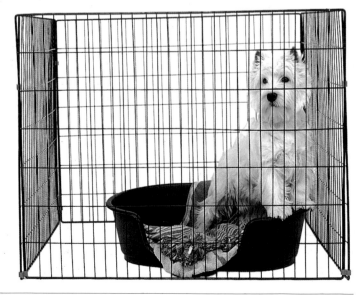

Collection

At least two people should collect the new puppy, and he should travel on the passengers' knees. He may never have been in a car before and he will be separated from his family for the first time, so he'll need comforting. Take a supply of tissues, a towel and a little water, as the puppy may be travel sick. Do not take him out of the car at lay-bys, as these are serious sources of infection.

At home

Back at home, let the first day be peaceful. Give the newcomer a name, give him time to explore, be with him, talk to him and play gently with him – he shouldn't be harassed in any way. This is an important training period, and what you do now will set the pattern for the future. Modern behaviourists advocate not permitting a puppy to sit on the furniture in case he gets ideas above his station. However, I live with many terriers and let them sit where they want – they get down if I want the seat!

Night-time

The first few nights may present problems, so surround the box with newspaper in case the puppy wants to urinate. Put a well-covered hot water bottle in the bed and leave a radio playing all night. It is not kind to let the puppy howl all night. He will be lonely and it is not unknown for some new owners to sleep in the same

CHILDREN AND THE PUPPY

Instruct the children that the dog's bed is his private sanctuary; it is inviolate and when he wants to sleep he must be allowed to do so without disturbance. Just as a baby needs a lot of sleep for growing purposes, so does a puppy. Terriers generally get along well with children, but no puppy can be expected to suffer pain, however accidentally at the hands of youngsters. He will not know, nor care, that it is accidental; he knows only one method of retaliation or defence, i.e. a nip with sharp teeth. A well-socialized puppy will bite only as a last resort when he's either hurt or frightened. You'll find that the children will live on a higher level, while the puppy will enjoy dragging about the clothes they have left on the floor. Their tapes and other things they value will be toys and chews to him – he may teach them a valuable lesson!

room as their puppy. Some allow him to sleep in his box by the side of their bed; a hand touching him at night is a comfort. However, it is not a good idea to allow him to sleep with you in your bed.

■ If you don't want your pup to go upstairs, then fix a child-proof gate at the bottom. If he does go with you, make sure that you carry him up and down. He is likely to injure himself severely if he falls downstairs. He is still very small and his bones will not set until he reaches about six months.

VETERINARY SERVICES

Check the vets in your neighbourhood, and find one whom you like. Talk to him about your proposed puppy, and be guided by him as far as vaccination and worming are concerned. Buy your worming preparation from him and follow the instructions carefully. Even if your puppy has been wormed regularly by the breeder, he is likely to have round worms and you will need to administer the drug within two weeks of acquiring him. Dispose of the faeces down the toilet or burn them. Simple hygiene will prevent any infections spreading to the family or to the public.

Vaccination

■ Modern vaccines are almost 100 per cent effective. Distemper and parvovirus are still killer diseases, and a puppy of eight to ten weeks of age is unlikely to have been vaccinated. He will have only a vestige of antibodies left for countering these diseases, so you should not allow him to venture out in public places until you have the vet's approval, for fear of infection.

■ First vaccinations should be administered at about twelve weeks, and the boosters two weeks later, after which the puppy will be safe from infection. Keep the certificate in a safe place as you

INSURANCE

Puppies and elderly dogs are most vulnerable to disease. It is wise to take out insurance against disease because of the ever escalating costs of veterinary services. Several reputable companies offer many different levels of cover, and it is certainly wise to insure puppies against the veterinary costs of treating disease or accident. West Highland White Terriers are a hardy breed and you may never see a vet except for vaccination purposes but should it prove necessary you will be glad you had the foresight to insure.

will need it if your dog ever goes to a boarding kennel.

■ It is useful to familiarize the puppy with the local geography by carrying him around and getting him accustomed to the noise of heavy traffic. Don't put him down and expose him to infection. There's no need to worry about exercise for the first five or six months; his normal activities of playing and running around in the house and garden will be quite sufficient.

■ When he is able to go out, make sure that you show him all the routes leading back to your house. This simple procedure will help him if he ever gets lost.

FEEDING

It is relatively inexpensive to feed a small dog properly, even on high-quality food. At eight weeks old, a puppy's stomach is probably no bigger than a table-tennis ball, and he will require small quantities of nutritious food six times a day together with a continuous supply of fresh water. Follow the instructions on the diet sheet you were given, or those on the can of puppy food. Feed the best food available, always at the same time and in the same place, and never directly from the refrigerator.

■ If the puppy does not eat immediately, do not leave the food down for too long in case insects contaminate it. Don't allow him to eat the cat's food or milk, nor should the cat and dog be fed together. Some dogs react unfavourably to cow's milk, so check with the breeder as to whether he is used to it. If not, don't risk feeding it; he can live and prosper on water.

Supplements

If good proprietary foods, such as canned meat mixed with wholemeal biscuits, or complete diet foods are used, they will be balanced scientifically and there will be no need for vitamin or mineral supplements. However, if you mix your own, it probably won't be balanced and

OLDER PUPPIES

As the puppy gets older, he needs fewer meals but larger quantities of food, until at the age of between six and eight months he eats two meals a day. It is not wise to feed dogs with titbits from the table. If you don't start, your dog won't bother you when you are eating. Greedy dogs are likely to get fat and unhealthy. Train the children not to give him sweets, sugar-based biscuits or cakes; he'll eat them but they're not good for him.

any amounts of additional supplements should be considered carefully because too much or too little can easily upset the puppy's development. Seek the advice of your vet. The most common health hazard is diarrhoea, which can be caused by different water or a sudden change of diet. Eliminate all dairy products and feed only boiled rice and chicken. If there is no improvement in twenty-four hours, take the puppy to the vet.

TRAINING

Contrary to some beliefs, a puppy is never too young to start the training process. It all depends on the way in which it is done. Gentle firmness should be combined with lavish praise and reward. There are four areas in which both you and your puppy can benefit from an early start:

- Toilet-training
- Grooming
- Walking on a lead
- Basic obedience

Toilet-training

- When a puppy wishes to urinate or defecate, he will invariably do the same thing. He may turn in circles, he may run backwards and forwards or he may go to the same spot each time. It is up to you to be ready and, when he goes into his act, to interrupt and put him outside. Wait for him to perform, praise him and call him back into the house.

- Get into a routine: put him out regularly at the same times – when he gets up in the morning, after every meal, after every period of rest, and last thing at night. Remember always to wait and praise him after the performance. By all means grumble at him if he does it in the house but only if you actually interrupt him in the process. Scolding him after the event will achieve nothing as he won't relate your displeasure with the action. Rubbing his nose in the mess is equally pointless. In fact, it is probably more unpleasant for you than it is for him! Hitting him will make no difference; he will not relate his natural functions with punishment. Don't preface grumbling or shouting with his name – when he's young, you must make him associate the calling of his name with pleasant things.

- Put quantities of newspaper down on the floor, making it easily accessible. When he uses it, gradually make it smaller until there's only one sheet. Move it gradually each night, a little closer towards the door. When it reaches the door, it's easy to leave it on the step. Just be careful not to leave the newspaper you are reading on the floor by your armchair at night!

Grooming

- Because of the type of coat the adult Westie grows, it is vital to get him used to being groomed when young. Start by standing him on a table and brushing and combing him gently in the direction the hair lies. He'll play-bite the brush but you should ignore this; eventually he'll stop.

- Once a day, pull a few of the long soft hairs out with the finger and thumb and

WALKING ON A LEAD

■ Buy a cat collar and a light lead, and put the collar on the puppy during the daytime. Take it off at night. He'll soon get used to wearing it. After a couple of days, attach the lead and let it trail on the ground until he ignores it. Keep an eye on the pup in case he gets tangled up in the lead. Don't rush things; it may take a day or two for him to get used to the lead.

■ Pick up the lead and let him walk about, going where he pleases but at the same time asserting a little pressure. Try this several times during the day. When he's ready, holding the lead, draw him gently towards you, calling his name. When he gets to you, award him with a titbit, e.g. a piece of fried liver, and praise him. Very soon he'll walk happily beside you; just don't let him pull.

TRAINING CLUBS

There are many training clubs run by enthusiastic dog people, and they are advertised in the local press. Alternatively ask your vet if he knows of a class in your area. In the UK the Kennel Club will advise on clubs operating their 'Good Companion' scheme, which enables owners to teach their dogs simple obedience so they can fit into society. Upon the successful conclusion, a certificate is awarded. The tutors should use modern gentle methods; harsh training is a thing of the past and, with patient care, your dog will be a credit to you and his breed. Reinforce the training at home – in the initial stages he is likely to forget rather quickly, as once a week training is not enough.

Clubs fall into several categories, and the pet owner who just wants a well-behaved dog should seek a general training club making sure they teach domestic obedience or the Good Companion course. Other clubs specialize in teaching both owners and dogs the skills of dog showing. Both types are social occasions and bring together different people with a common interest.

shape him up a bit. He'll object and probably jump about but it won't hurt him. He'll stand still after a few days so be patient. When later he has to be stripped for showing or clipped, this early work will pay dividends. Unless he wallows in muck there's no need to bathe the Westie often – regular brushing will remove the dirt.

Basic obedience

■ Start by teaching your puppy to sit and come on command. To teach him to sit, apply a little pressure on his back by the tail with one hand while lifting under the throat with the other. Say 'sit'

Regular grooming will keep your dog's coat in good condition. Combing the foot hair will prevent it matting.

regularly. Do this a few times twice a day, and soon he'll obey.

■ After he has become used to the collar and light lead, attach a long cord, 4-5 m (12-15 ft) long. Starting from about 1 m (3 ft) away, tell him to 'sit', then wait a few seconds and call him by name, adding the word 'here'.

■ He'll ignore you but have a small titbit handy as a reward and tempt him

forwards. Gradually extend the distance at the end of the cord, still commanding him to sit and then calling and rewarding him.

■ When giving him his reward, hold it in front of him. If you feed from a height, he'll spend his time looking up at you and for showing purposes this will give him a disastrous outline. Five minutes twice a day are all that is needed. Keep these training sessions light-hearted and enjoyable for both you and your dog.

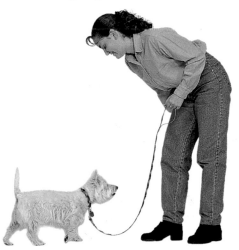

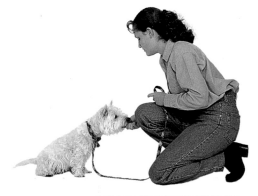

THE ADULT DOG

TRAINING AND OBEDIENCE CLASSES

If you have followed the advice in the earlier chapters of this book, by the time your Westie reaches adulthood, which can vary with the strain from around fourteen months to over two years, he should be trained at least in the fundamentals and be under control. By 'control', I do not mean that the dog should be subdued; indeed, he should have all the fire and exuberance expected of the breed. Mischief and playfulness are by-words for the West Highland White Terrier and this state of affairs should last into old age.

In Europe, the West Highland White is not renowned for successful formal obedience training or agility; in fact, very few terriers are trained in this way. However, there's no reason why they should not compete with other breeds of dog, and in the United States, many terrier breeds have reached high levels in competition.

When terriers go to dog-training sessions, they are sometimes met with

Serious dogs walk on four legs, not two!
Westies are active little dogs and love
playing games.

incredulity from the owners of German Shepherds and Border Collies. They tend to consider that their dogs are the only ones worthy of competition. However, perseverance will eventually produce results, although occasionally, a terrier will create an independent run only to amuse himself – he is not a serious dog.

OLDER RESCUED AND RE-HOMED DOGS

It is sometimes possible to buy a dog between six and twelve months old. Breeders may 'run one on', meaning that they keep a puppy to see if he develops well enough for showing. However, if he does not fulfil their expectations, he will be found a home. This does not mean there is anything seriously wrong with the dog; it is just that some feature, e.g. the set of his ears or a misplaced tooth, is not quite right. If you have no intention of showing or breeding, then there is no reason why you should not consider buying such a dog.

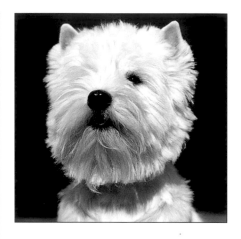

On the positive side, you will not go through all the work associated with a puppy, but, on the negative side, the young dog will not have been schooled in the way another owner wants and he may have unwanted faults. If so, it may take considerable time, patience and expertise to put things right.

■ Rescued dogs

The same problems may occur with a rescued dog. Several of the major welfare societies take in stray and unwanted dogs, which can include pedigree animals. After examining them, most societies will try to home them within a week or two. In most cases, they are not aware of why the dogs are unwanted – for example, they may be biters or barkers, but there's no way of finding out unless you live with them.

■ Re-homing dogs

West Highland White Terriers are fortunate in that they have very good breed rescues. In Great Britain, this is a re-homing service, and the reasons for an unfortunate dog's situation are often known. For example, he may be the victim of a marriage breakdown, the death of his owner or some other unavoidable circumstance. Breed rescues will take the dog in, have it vetted, pay for any necessary treatment and keep him long enough to find out whether there are any behaviour problems. They will also investigate anyone who wants one of their dogs. In these cases, it is possible to find a well-trained dog who will make a fine addition to a family.

TRAVELLING WITH YOUR DOG

From an early age, your dog should be trained to travel in a car, and you must try to make a car journey an enjoyable experience.

■ Play with him in the car when it is at a standstill for ten minutes a day for two or three days. Do the same for the next three days with the engine running, and then try driving the car slowly for just a very short distance over the next few days. You can even feed him in the car.

■ When you finally take him some distance, always take him to a place where he can enjoy himself, such as a park or the countryside, and eventually he should associate car travel with pleasure and the enjoyable prospect of a walk.

WARNING

It is vital that no dog should be left in a car in the sun. The interior temperatures can rise astonishingly in a short time, and the dog can die in a few minutes even with the windows open. It is worth remembering that a Westie can wriggle through a 10 cm (4 in) gap, so be careful. It is not safe to drive with a loose dog in the car, with two terriers it can be positively lethal! Special dog guards to separate dogs from humans are made for most makes of car, while specially designed cages which fit the shape of the modern estate car's sloping back are also available.

A specially designed dog guard will help to keep your Westie safe.

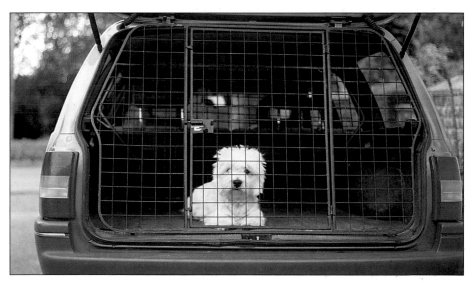

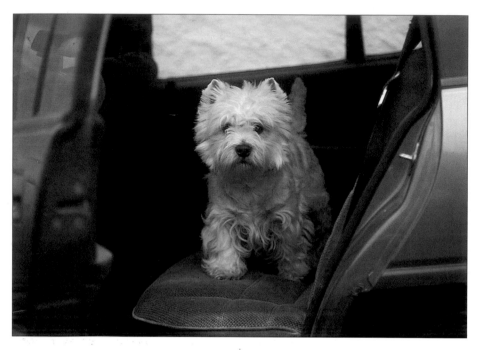

Train your dog to wait for his lead when you open the car door. A travel box is a safe alternative.

■ There is a dangerous moment when you arrive at your destination and open the door. Your Westie is likely to jump out like lightning, and this is where your 'sit' training is invaluable. When the car stops, command him to sit and wait, and then open the door and get out. Only let your dog out when you are ready. This will give you time to put his lead on.

Travel boxes

■ It is acknowledged that the best and safest way for dogs to travel is in a travel box. This prevents them being thrown about by the movement of the vehicle, and also gives them a sense of security.

■ In an accident, it is not unusual for rear doors and tail-gates to fly open, throwing loose dogs into the road and putting them at risk from overtaking traffic. Sometimes they are so terrified that they disappear and are never found. Remember also that even at relatively low speeds, loose dogs can be thrown through a car windscreen.

■ It is not cruel to put a dog into a box; they enjoy the security. The box or cage can be used also as an indoor kennel providing it is the correct size, about 35 cm (14 in) wide, 47 cm (18 in) high

and 55 cm (22 in) long. This allows the dog plenty of room to lie full length and stretch out.

■ Train your dog to go into it by feeding him inside it with the door open for a few days. Then shut the door for a few minutes, and finally leave the door shut for about an hour. This is very useful training if you want to go shopping for an hour or so. Alternatively, you can put him in the box if he wants to kill the vacuum cleaner! Do not over-use this device in the home, as you want your dog to be a deterrent to unwelcome visitors!

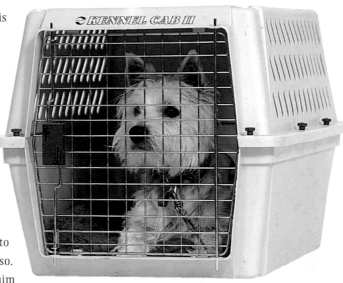

Your dog will enjoy the security of a lightweight, airy travel box, with room for him to stretch out.

IDENTIFICATION

In a public place, at all times, the law requires your dog to have an identification disc on his collar. This should bear your name, address and telephone number. Do not have it engraved with the dog's name; there's no point in helping dog thieves. On the reverse side, it is suggested that the word 'Reward' appears, as this often helps to get him returned if he gets lost, especially if children find him.

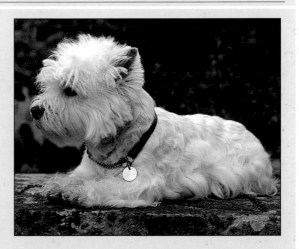

FEEDING THE ADULT DOG

As with puppies, you should continue to feed high-quality food at the same time each day. When a dog's stomach is full he is liable to be less watchful than when it is empty. Giving a dog his main meal in the morning will make him more watchful at night; the reverse is also true, and a night-fed dog will sleep more soundly.

If it is true that we are what we eat, then it is the same for dogs. They are remarkable creatures and can subsist on virtually any food, but in order to be healthy and long lived, they need a balanced diet containing the right amounts of protein, vitamins, fibre and fat. Off-the-shelf convenience pet foods are a fast growing industry, and apart from the obvious benefits, the major pet food manufacturers employ nutritionists to carry out research into a pet's dietary needs and to formulate feedstuffs with every contingency in mind.

Which foods?

■ You should be aware that certain foods suit certain dogs better than others. Modern dog food marketing has convinced many people that the higher the protein value, the better the food. However, this is not true as too much protein is as damaging as too little. If your Westie is extremely active and runs many miles each day, or goes hunting foxes and rabbits, he needs a food that is high in protein. But if he is your average Westie, playing in the garden chasing a ball and enjoying a couple of short walks each day, he does not.

■ All prepared dog foods have the protein content written on the packaging. The average Westie needs between fifteen and twenty per cent protein in the manufacturer's terms. There are foods to suit all sizes and

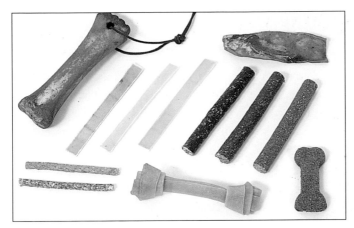

A selection of treats and training aids. Edible chews make safe and enjoyable treats and are preferable to bones.

activities, the suitability of which is plainly marked on the packets or cans.

■ If you feed your dog with food you have prepared and cooked yourself, take care if offering any additional supplements – too much or too little will harm the dog. Ask your vet for advice.

How many meals?

Controversy as to whether to feed two meals or one meal a day has raged for hundreds of years. My view is that we don't like being hungry, and neither does a dog. Therefore, I give my dogs their main meal in the morning and a snack in the evening.

■ The only treats a dog should have are dog-food based, e.g. hard biscuit bonios and edible chews. Bones of any description should not be offered as cooked lamb, pork and chicken bones split into jagged pieces and can pierce the stomach lining. Some people advocate the use of big marrow bones, but a terrier's jaws and teeth are so strong that they can crumble the bone and swallow it. Over a period of time, it can get trapped and become impacted in the digestive tract. If this happens, an operation will be needed to remove it.

■ Another reason for not feeding bones is that some dogs get very possessive over a big juicy bone and become ferocious in its defence. Children and other dogs are at risk unless the dog has been trained to give up his food. Even then, he may only give it up to the person he considers to be his pack leader. It's better not to give him any temptation.

Skin problems

Too high a protein value can cause skin problems in most dogs, and in the West Highland White it can be a serious condition. Any sign of changes in the skin colour or texture, or any sore spot

should be reported immediately to your vet. The dog's diet may have to be changed to a chicken and rice combination; alternatively, your vet may recommend a special low-protein regime. All dairy products should be stopped, and no human food treats, such as cakes and biscuits, given.

Some terrier breeders have found that dogs with harsh coats benefit from the addition of oil in their diet, and that one capsule of cod liver oil or a teaspoon of olive oil or corn oil two or three times a week helps keep skin and hair healthy. The major manufacturers have special departments to advise customers so consult them if you have a problem.

A dog in sparkling condition shows a lively, intelligent interest in his surroundings.

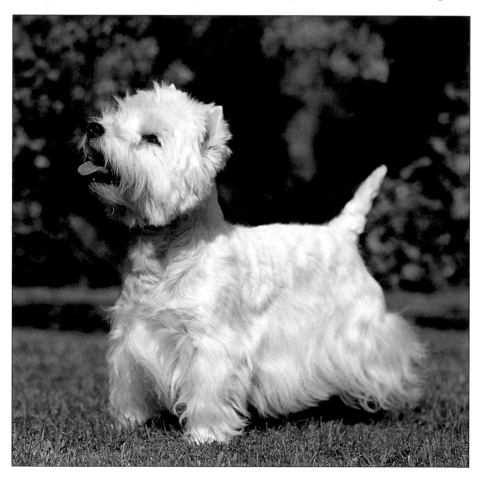

NEUTERING

There is an on-going discussion on the merits of neutering pet dogs and bitches, and for reasons not fully understood more bitches are spayed than dogs castrated. Under no circumstances should you consider either of these operations if it is your intention to show the dogs under Kennel Club rules, as neutered animals can only be shown after they have produced progeny.

Bitches come into season from six months old and thence about twice a year with variations, into old age. Some people believe that bitches should be

allowed at least one litter to prevent them from having infections of the womb later in life, but there is no scientific evidence to support this theory despite what is said by some members of the veterinary profession.

The in-season bitch will attract the attentions of all the males who pick up her scent, and she must be kept in isolation for about three weeks, or until it is over. If not, she may be mated by any stray dog and produce a litter of mongrels which will probably increase the stray dog problem and overload the services of canine charities which exist to find homes for unwanted dogs. It is now considered anti-social to have a litter of unwanted puppies, so steps should be taken to avoid it.

ACCIDENTAL PREGNANCY

If a bitch becomes pregnant accidentally, a vet can terminate the pregnancy with one injection. It is possible to stop the season chemically, and a vet can supply a course of tablets which, if started in time, will prevent the onset of her season. However, this is not always satisfactory because the balance of her hormones can be disturbed and induce side-effects.

SURGICAL NEUTERING

For complete peace of mind, surgical neutering is the only realistic option. Always make the decision in consultation with your vet. A spaying operation is routine and your bitch will recover from the anaesthetic within a few hours, and will return to normal very quickly. Some people suggest that her character will change but there is no evidence to that effect. The benefits are that she will never come into season again and will never suffer a false pregnancy. Sometimes the act of neutering either a dog or bitch will cause the coat characteristics to change, possibly softening and thickening. There is also some evidence that both sexes tend to put on weight after the operation so more careful control of the dog's diet will be needed.

Males

Some vets and behaviourists believe that the castration of a dominant male dog will alter his character and stop his aggression. This is open to question as it is the body that is altered and there is no proof that instincts and thought processes undergo a change. If the dog is a wanderer, it will not make any difference. However, you will have the satisfaction of knowing that you are not contributing to the problems of canine over-population. The operation itself is very simple, and the dog will recover in a couple of days.

Play is a form of exercise, keeping dogs fit and healthy and developing their muscle and intellect.

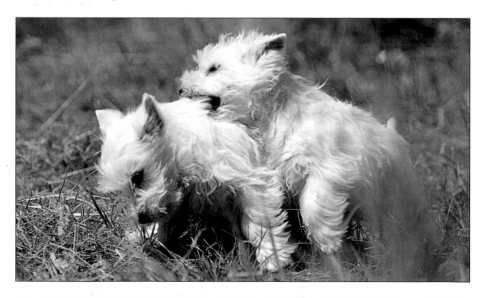

EXERCISE

To be healthy and happy, the adult Westie needs plenty of exercise and things to do. He is a naturally active and inquisitive dog, and although he can get by on the minimum of daily exercise, he needs free running and play to stay fit and in good condition. He can be taught easily to retrieve a ball, and thirty minutes spent throwing a ball in the garden each day will keep him in hard, muscular condition. Give him things to tax his mind: hide the ball and let him find it or throw it into thick vegetation. The more contact you have, the happier your dog will be.

He should be trained to defecate on your own property, but all dogs can make mistakes so when you are out walking your dog, be sure to carry something for picking up any dog's mess on public land. Things are better in the country but if you exercise your dog on farmland you should not allow him to venture near livestock, especially sheep. Remember that a farmer is legally entitled to shoot a dog if he believes it to be a threat to his animals.

WALKING ON THE LEAD

If you live in a town, two short walks a day on the lead are probably all that your dog needs. Make a point of never letting him off the lead – the Westie is so inquisitive by nature that if something attracts his notice he may run off, oblivious to your entreaties. If he crosses a busy road, he risks his life. An extending lead is useful as it gives the dog an illusion of freedom but the handler always stays in control.

BOARDING KENNELS

The quality of the service offered by boarding kennels varies considerably, and it is sensible to visit several kennels to check them out. Rates will vary, but, in general, the more facilities a kennel offers, the more it will cost.

Boarding tips

■ Visit the kennel and ask to be shown around. Look for clean, sweet-smelling quarters with toys and soft bedding.

■ Once you have settled on a kennel, discuss the feeding and make sure that the staff understand any special needs your pet may have. Get a quote for what it is likely to cost.

■ It is a good idea to leave a used sweater with the dog so that your scent will be a comfort in your absence. Try not to worry too much; it is surprising how most dogs will settle into a boarding kennel if the staff are sympathetic.

■ Ask them which vet services their kennels and assure yourself that they will not hesitate to call on him should the need arise. Last, but not least, make sure that the insurance is paid up.

Inoculation

Good kennels will expect up-to-date inoculation certificates

against the principal infectious diseases on arrival. It is advisable to add a vaccination against kennel cough. It is not normally a killer disease, but it is uncomfortable for the dog. If your return date is delayed, let the kennels know as soon as possible.

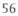

BEHAVIOUR PROBLEMS

It is not difficult to train and to socialize a puppy from an early age. However, allowing for a dog's natural instinct and heritage, you cannot expect a West Highland White Terrier to behave like a small human being. He will behave like a terrier: a dog with an independent spirit.

There are two main reasons why dogs can be difficult. The first, quite simply, is incorrect training and handling when young, and this can be blamed on the owner. In such cases, the owner cannot correct the dog's behaviour because he created it in the first place. A veterinary surgeon would usually refer such an owner to a dog behaviourist who would help solve the dog's problems. However, the owner too should learn how to handle the dog because unless the new training is reinforced, the dog will revert to its original type. A good dog trainer could be in a position to correct faulty behaviour, particularly if he has watched the dog since he was young.

The other reason for difficult behaviour is the possibility that the dog is slightly insane. If it happens with humans, it can happen to a dog. If nothing can be done, it would be kinder for the dog to be put down humanely.

VACCINATIONS AND WORMING

■ **Vaccinations**
Annual booster vaccinations are necessary to maintain your dog's antibody levels against the five main diseases of canine distemper,
■ Canine parvovirus
■ Infectious canine
■ Hepatitis
■ Leptospirosis
■ Kennel cough.
Your vet will usually send a reminder.
■ **Worming**
Regular worming, usually to control round worm, is essential. It is necessary for the health of your family and your dog. A worm infestation will adversely affect his condition: he will look poorly, his coat will have a lank and unhealthy appearance and he may suffer skin disorders. In extreme cases, dogs can even die of worm infestation. Bitches harbour more worm larvae in an inert state in their bodies than dogs. The larvae are activated with the hormonal changes occurring when the bitch comes into season or when pregnant. Because of the ease with which dogs can re-infect themselves, your vet will probably recommend worming three or four times a year for an adult dog.

GROOMING

There are two levels of grooming a Westie: the pet level and the show level. If the coat is allowed to grow long, it will matt and tangle unless it is combed on a regular basis. Three times a week would be ideal.

Keeping fleas at bay

An unkempt coat attracts parasites, especially fleas. Animals such as free-ranging cats and hedgehogs carry fleas which could infest your dog and cleanliness is irrelevant. Even the cleanest dogs can gather fleas.

■ Don't buy any off-the-shelf flea spray; some are toxic, especially to puppies. Your vet will have the appropriate treatment. Be sure to spray the bedding

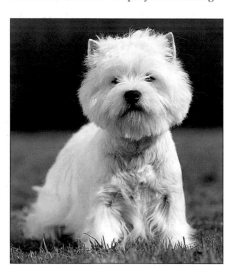

and its surrounds to prevent the life cycle of the flea continuing. Anti-flea shampoo is available but it is not necessary to bathe a Westie very often.

Grooming routine

Although it is comparatively easy to groom a West Highland White, it is also a good idea to take a pet dog to a professional grooming parlour three or four times a year. In this way, the shape of the coat will be maintained although it will be clipped and scissored.

The correct way to groom a Westie is to pluck the hair and keep the thick undercoat under control – this is what the show people do. Some pet groomers use a combination of the two methods, thereby allowing plenty of the correct textured hair to grow through. Teaching how to prepare a dog for showing could be an entire book in itself! It is an ongoing procedure, taking considerable time and practice. If you want to show your dog, you would be well advised to study photographs of top show dogs, look at them in the ring and talk to the breeders and exhibitors. Occasionally, there are specialist teaching seminars where the serious learner can gather all the information he needs on show preparation. There is more detailed information in Chapter Six on show grooming.

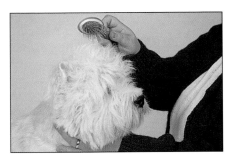

When grooming your West Highland White Terrier's head, always brush the hair upwards for shaping.

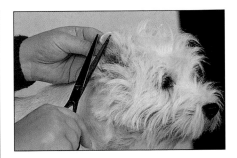

Carefully snip the inside ear hair to keep it short and thereby help keep ear mites at bay.

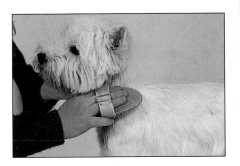

Use a specially designed terrier pad to remove any loose hairs and stimulate the growth of your dog's coat.

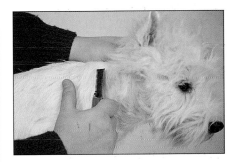

You should learn to use a stripping knife to remove any excess hair and thin out the top coat.

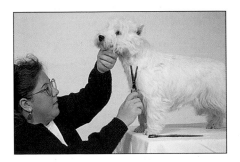

You will need sharp scissors to keep the hair short under the throat and reveal the dog's neck line.

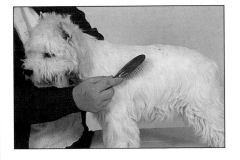

Always brush the Westie's coat in the direction of the lie of the hair. He will enjoy being groomed and brushed.

When hand-stripping your Westie's coat, gently hold the skin in front of the knife with the other hand.

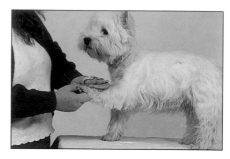

Use a terrier pad to brush up the front leg furnishings. Your dog will grow accustomed to standing still.

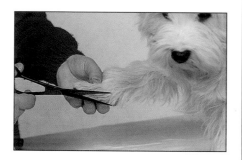

Carefully trim around the feet with a pair of sharp scissors in order to maintain their shape.

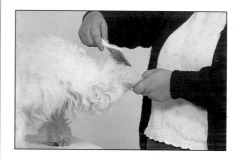

The hind leg furnishings must be kept clean and free of matted hair with regular brushing.

Carefully cut out any excess hair from between the pads; this is done for comfort and to aid good movement.

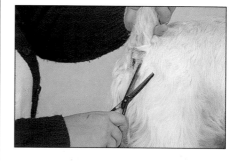

Keep the hair short around the anal area for obvious reasons of hygiene. Always use scissors with care.

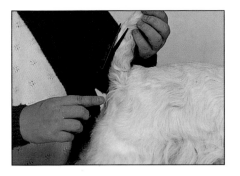

Use a pair of sharp scissors to carefully trim the hair of the tail.

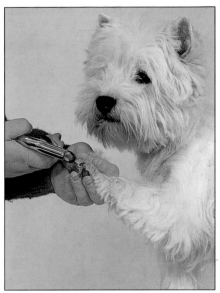

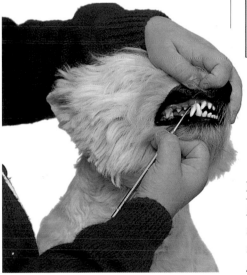

It is necessary to clip the dog's nails and keep them short; you may want to ask your vet to do this for you.

Dental care

Regular dental care will help to preserve teeth. Canine tooth brushes and toothpaste are available. Instruments should be used only under supervision.

BATHING

Dry shampoos are available, but regular brushing should keep your dog's coat clean. If you really want to bathe your dog, use only specially formulated dog shampoos or a human baby shampoo. Whichever you choose, always take care to protect the eyes. Make sure that your dog is thoroughly rinsed and is totally dry before allowing him to go outside – Westies are hardy dogs but they should not stay damp for long periods of time.

BREEDING

PREPARING FOR BREEDING

Nobody should breed West Highland White Terriers without giving the matter a great deal of thought and careful consideration. Breeding dogs to earn a bit of extra cash for a holiday is not acceptable. Not only will you be bringing little animals into the world for which you must bear the responsibility but you are also entering the realms of the breed fancy extending back over one hundred years. You should not breed dogs if your motivation is anything other than the wish to breed excellent specimens for the future of the breed.

Ignorant breeding

Caring properly for a litter is expensive and time consuming. The bitch will require some privacy, and the new family should not be left for long periods. Although many people believe that nature knows best, avoidable accidents still happen.

The Westie is one of the most popular terrier breeds and consequently is subject to the 'get rich' commercial breeders who very often have no consideration or understanding of genetics and are probably guilty of introducing hereditary anomalies and puppies of inferior quality. It can take the genuine fancier years of work to breed out the problems created by ignorant breeders.

Knowledge is the key, so begin by reading everything available on the breed. If the breeder of your bitch is recognised as being successful and is held in esteem by other breeders, it is worth consulting him. Most breeders will help the novice through all the various stages, starting with advice as to which stud dog is suitable for a particular bitch through to the sale of the puppies.

BREEDERS' LICENCES

In many countries, there are laws governing the breeding of dogs. In Great Britain, for example, you will require a breeder's licence, available from your local council, should you have two or more breeding bitches. There is also special consumer legislation to protect purchasers of puppies, whereby if they complain about the suitability of a puppy it is necessary for breeders to show that they taken advice, have considered all known genetic factors and have acted in good faith.

Stud dogs

You may think that any stud dog will impregnate a bitch, and indeed this is true but will the resultant puppies be of a sufficiently high standard? To produce puppies of the highest quality, the stud lines must match the bitch lines, and this type of information can come only from people experienced in the breed.

■ Make certain that the chosen dog is

Watching a mother with her young puppies is one of the great pleasures of breeding Westies.

registered properly with the Kennel Club. If this is not the case, the resulting puppies cannot be registered or exhibited.

■ A fee must be paid to the stud owner at the completion of a mating, and the amount varies between different breeds

and breeders. However, this should be agreed at the onset. Usually the fee will cover two services in the same season by the same dog; it is for the mating and not the results.

■ If no puppies result, most bona fide breeders will offer the next mating free of charge. This is a concession, not a rule.

■ Some breeders will loan out bitches in return for puppies, but this is not a good idea and often leads to action in the courts.

MATING

An experienced stud owner will manage the mating without problems if the bitch is ready. It should be easy with no stress for either animal. Forced matings are not advisable, and there should be no need to muzzle the bitch. A 'tie', in which both dogs are tied together for anything from ten minutes to an hour, is natural and preferred, although not entirely necessary. The semen passes from dog to bitch within the first twenty seconds or so, and therefore the reason for the tie is unknown. The stud owner will give the bitch owner a signed Kennel Club form as confirmation of the mating, the date and the dog used, together with a receipt for the money paid.

THE BITCH

You should not breed your bitch during her first season; nor should she have puppies after the age of eight years if the litter is to be registered with the Kennel Club. Make sure that her vaccinations are up to date so that the puppies will have plenty of antibodies at birth. It is also advisable to worm the bitch before mating her, although it can be done during pregnancy. If in doubt, ask your vet.

The bitch in season

The scientific term for a 'season' is oestrous, and a bitch will come into season about twice a year. This varies considerably within the breed; it may be three times in two years.

■ The first sign is a bloody discharge from the vulva which, in anything from nine to eleven days, will change to a straw colour when the bitch is ready for mating. The timing will vary with each bitch and season.

■ Another sign of readiness is when the tail twitches from side to side if slight pressure is applied near it when the bitch is standing.

■ The signs should be monitored carefully because the period of time during which the bitch can conceive is limited.

■ A vet can carry out special tests to determine the ideal time for mating but, overall, the dogs know best.

■ It is usual for the bitch to be taken to the dog for mating. Distance should not come into the equation, the aim being to find the most suitable stud dog.

The right time

There are variations in terms of which day is right. If the bitch will not accept the dog, the chances are that it is too early. Most stud owners will keep the

Even when a bitch is heavily pregnant, she should still have some light exercise.

bitch for a day or two, trying each day, but a successful mating does not necessarily mean that the bitch will conceive. Infertility in both dogs and bitches is not unknown and after a failure, for any reason, veterinary help should be sought.

After the mating the bitch should be taken home quietly and treated normally. There are subtle signs if she is pregnant:

- She may be quieter than usual.
- Her teats may increase in size.
- She may have a colourless discharge after two or three weeks.

The period of gestation varies from fifty-seven to sixty-nine days, with the average being sixty-three days.

Confirmation of pregnancy

Many novices want to know as soon as possible whether their bitch is pregnant and how many puppies she is expecting. Ultrasound scanning is the only reliable method but puppies can be detected only at the correct time. It is possible to palpate the bitch, and, by feeling very gently, the heads can be counted between the twenty-first and twenty-eighth days. Veterinary blood tests will detect pregnancy but not the number of puppies. Later in the pregnancy the movement of puppies can be seen and felt.

Pregnancy

For the first four weeks, you should follow your usual routine, with normal exercise

DIET

Milk and eggs can be added to the bitch's diet together with a teaspoon of corn oil or olive oil, her motions should be regular and firm. I have always administered a raspberry leaf tablet during the last week, which I think, facilitates the birth process. At this stage the food intake may be increased by up to twenty-five per cent given in four or five portions during the day.

and feeding high-quality food. Administer one capsule of cod liver oil daily, but do not take the advice of anyone other than expert breeders or your vet. Over-feeding and over-supplementation can have disastrous effects. You may need to exercise a little more care than usual to prevent the bitch from jumping and falling, but exercise should be taken regularly.

At four weeks plus, the bitch should have more food, but bear in mind that as she becomes distended her stomach will be less capable of taking the food, and therefore her meals should be divided into two parts. You might also consider increasing her vitamin and mineral intake, but take care not to exceed the recommended amounts – ask your vet for advice.

In the last week, prepare a room ready for the whelping. Ideally, the temperature should be in the range of 18-21°C (70-75°F). Ensure that the bitch can be left in peace, without disturbance by other animals or children.

WHELPING PREPARATION

You will need a whelping box, which is capable of being closed but well ventilated. It should have a door with a flap at the base to ensure that the puppies cannot fall out or follow the bitch when they begin to walk. Pig rails should be fitted around the inside four walls, set 7.5 cm (3 in) above the floor to prevent the bitch rolling on her young – puppies can squeeze under them for safety. Ideally, the box would be approximately 90x50x50 cm (36x20x20 in) to allow the mother to

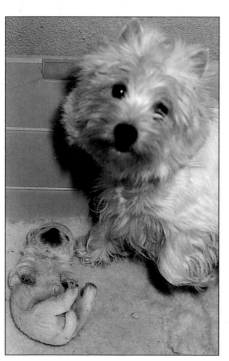

move freely and stretch out. This is important when suckling a large litter.

Such a box will prevent the puppies from straying too far from their litter-mates and suffering from cold; the correct temperature range is vital for their growth and wellbeing.

Heating

Some breeders use an infra-red heater hanging on chains, but care must be exercised with the height adjustment. If placed too close, it may burn the bitch's back. I prefer to use an aluminium heating pad placed under a man-made fabric known as a 'Vetbed'. The mother can escape from its heat by lying at the side of the pad. The use of this type of bedding enables the babies to get a purchase on the surface with their needle claws when they push against the teats to feed, thereby developing their leg muscles.

Contact the vet

When you're ready, all the preparations are complete and you have instructed the family to keep away, phone your vet and tell him when the birth is expected to happen. Hopefully, you will not need his expertise but it is just as well to be prepared. Remember to phone him when the whelping starts.

EQUIPMENT FOR WHELPING

Westies are fairly easy whelpers, and not a lot of equipment is necessary when the time comes. The following list is for guidance only.

- Newspapers
- Surgical scissors
- 30 cm (12 in) squares of clean old towelling
- Gentle antiseptic lotion
- A plastic rubbish bag
- A whelping box and heat pad
- A can of puppy milk replacer
- Little animal feed bottles and teats
- A book describing the birth process by a practising breeder

A WHELPING BOX

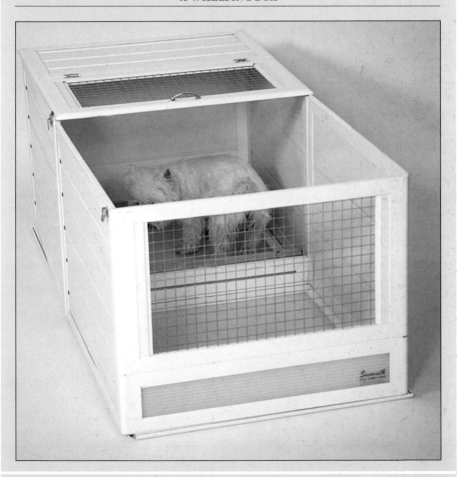

THE BIRTH

When it comes to whelping, there are no absolute norms – every birth is slightly different. For instance usually the bitch's temperature will drop from 38.5°C (101.4°F), which is the average dog's temperature, to anything between 36.1°C and 37.2°C (97° and 99°F) about twenty-four hours prior to the birth. However, sometimes it's only twelve hours before whelping. The bitch may refuse food in the twelve hours before the birth, but, then again, she may not.

INERTIA

This is when the bitch will either not start her contractions or she starts but nothing happens and they become weaker and weaker until she is exhausted. The first example is known as primary inertia, and the second is secondary inertia. Should you diagnose either condition you should call a vet immediately to administer a pituitary injection which should start her labour again within a short space of time. If the treatment fails a Caesarean section will be performed. However, this is comparatively rare in the breed. Do not be over anxious, many vets today have a tendency to perform Caesarean sections rather too quickly. In the breaks between deliveries, offer the bitch glucose water to replenish energy.

■ For the sake of hygiene and ease of birth, trim away the hair from the area around the vulva and anus, and away from the teats so that the new-born pups have easy access to their milk.

■ Some bitches appear very anxious, panting continually and scratching up the bedding or newspaper as their time approaches. They may do this for twenty-four hours or, alternatively, they may be calm up until the contractions start.

■ By now your bitch should be familiar with her whelping box. Keep a look out for signs of the first contractions.

Helping the birth

There is a school of thought that the bitch should be left to her own devices and that she'll know what to do by nature. The other school believes that we have removed dogs so far from their natural behaviour that it behoves us to assist as much as we can. The middle ground is probably the best, so observe the bitch and offer help and encouragement as necessary – family dogs like to be close to their owners at times of stress. Sometimes maiden bitches are scared of their own puppies and may not have a clue what to do and need encouragement, whereas others know by a powerful instinct.

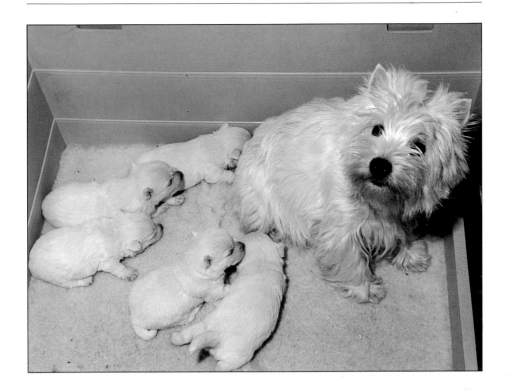

1 Scrub your hands and nails and wait. The first visible contractions are weak with a fairly long interval in between. They gradually get closer and stronger until you can see the strain.

2 The first sign of impending birth is usually a grey membrane, which looks like a balloon, protruding from the vulva. It contains a green fluid and can come and go many times before anything happens. Don't break this membrane.

3 When it is at its biggest, squeeze it gently. If hard, then it is the puppy bag and the other bag has probably burst of its own accord. When the first puppy

Bedding made of man-made fibre means that pups can move easily and maintain their body weight.

is born, break the membranes carefully with your nails. The puppy will still be attached to its umbilical cord.

4 Squeeze the umbilical cord between finger and thumb and cut the cord, leaving about 4 cm (1 1/2 in). Dispose of the after-birth (the placenta), expelled by the bitch, in a plastic bag. It is possible that the bitch may get to the placenta before you do, so don't worry if she eats it – this is perfectly natural. It contains

essential minerals and vitamins, and she will also want to clear it before any potential predators get scent of it.

5 Hold the puppy in a square of the prepared towelling, and clear away any mucus in the nose or mouth. You may have to open the mouth to do this, but all handling must be gentle. The bones are not yet ossified and can be damaged easily.

6 Hold the puppy upside down and dry him vigorously with the towelling. He should open his mouth and squeak.

7 A first-time mother can sometimes get a panic attack and be quite harsh with a new-born puppy because she doesn't know what to do. Keep her calm and don't let her do anything that you might regret. Don't let her persistently worry the umbilical cord.

Get the puppies feeding

During this time the bitch will be anxiously licking her newly arrived puppy. Let her do this as the experience will stimulate her milk. Put the pup on a teat – the two rear teats are richer in colostrum, which is the substance containing antibodies to counter the main diseases. You may have to express a drop of milk from the nipple and open the puppy's jaws. Place them around the nipple, teaching him how to suck. This is particularly necessary if the puppies are born early, as they don't seem to be programmed fully. The remaining

EASING OUT THE PUPPY

If there appears to be an obstruction and part of the puppy has emerged and stops, as sometimes happens with a breech birth, there is no alternative but to pull the puppy out. Hold him gently in the towelling and pull in time with the contractions. When the bitch stops contracting, you can stop pulling. Take it easy because the puppy is delicate.

puppies should follow in the course of the next few hours, and the time lapse will vary with each litter.

How many puppies?

■ It is not always easy to tell when all the puppies have been born and sometimes your bitch may surprise you and produce another live pup hours after the main event. Keep an eye on her for contractions, and count the number of after-births – there should be an equal number of placentas and puppies. When she settles down and sleeps with her young contentedly suckling, she has probably finished. Later the vet can give her an injection to clear any waste left inside her to prevent infection.

■ When she has finished, take her outside to relieve herself. She may be unwilling to leave her family but she must go. Her motions may be loose but this is probably due to the placentas

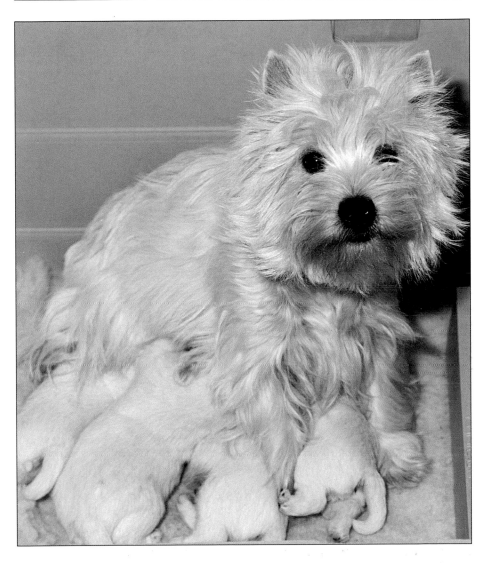

she may have eaten. At this juncture, it is of no great consequence. Take the opportunity to clear the whelping box of soiled paper and replace it with the 'vetbed'.

■ During the next eight hours clean the

A whelping box should be high enough to allow a bitch to sit up.

mother, using some mild disinfectant. Make sure that any residue is washed off to prevent the puppies ingesting it.

POSTNATAL CARE

The bitch will now become a milk producing machine. She will require three to four times the usual amount of food, with a constant supply of water and milk. Because of the enormous demands made on her system, she may have trouble in producing enough calcium for the puppies and suffer from a serious condition known as eclampsia.

She may puff a lot, appearing distressed around her puppies. She may be restless and if she staggers when she walks you must seek immediate veterinary attention. The vet will inject her with calcium boroglucinate and, as if by magic, the condition will disappear. However, if veterinary assistance is not called, she may die. You can help avoid eclampsia by supplementing the food with calcium and vitamin D. Ask your vet for advice.

Development of puppies

■ On the second or third day, the dew claws can be removed. If you have no experience of this, it is better that the vet attends to this minor operation.

■ Between ten and fourteen days, the puppies' eyes will open. Until this happens, there is little to do except keep the bitch's quarters clean and ensure there is an adequate supply of food and water.

■ As her family gets older, the bitch may

MASTITIS

This is another condition to which nursing mothers are prone. It is an infection of the milk-producing glands and shows itself as a reddening around the teats and a hardening of the breast. It will need the vet's attention. Meanwhile, bathe the whole area in warm water and gently express some milk to relieve the pressure.

want to leave them for short periods of time, and you should allow her to do this.

■ When the puppies' eyes and ears open, everything changes. Almost overnight, they will become more active and exploratory. After a few days, they will be quite strong on their legs and this is the time to let them out of the whelping box.

■ You can make an ideal play pen from the wire panels used for composting garden waste. Cover the floor with newspaper; this has the advantage of being the start of house-training. The puppies will wander out of their sleeping quarters to defecate and urinate – they do not like to foul their own nest.

Monitoring progress

The one sure way to monitor the progress of the puppies is to weigh them

Socialization starts at the earliest possible time, even when the puppy is very young indeed.

on a daily basis and carefully record the result. The weight gain should be even at around 42 g (1¹/₂ oz) per day in the first week. If there is a variation, the reason should be sought. For example, the mother's milk may be in short supply or not palatable, she may not allow the pups to feed, or their claws may be too sharp. If you cannot discover the reason, it will be necessary to supplement the puppies' food with milk replacer.

Weaning

The weaning process starts from about three weeks of age. The bitch will indicate that she wants to get away from her brood, and this is an ideal time to introduce the puppies to new foods. Perhaps the easiest way to do this is to scrape a piece of raw braising steak into a paste with a sharp knife and let the puppies lick it off your fingertips.

VACCINATION AND WORMING

A vaccine against parvovirus can be administered from about six weeks onwards – this is a wise precaution. Puppy wormers are available and should be given to the litter at about three weeks, and again at five and seven weeks. The mother should be wormed at the same time or she may reinfest herself from her own puppies when she cleans them.

In a short time, they will get used to this and will take the meat off a plate. This will lead naturally to feeding small quantities of scrambled egg with milk replacer and thence to a regular puppy food in cans or a complete diet made moist, whichever is best.

Milk

Let the puppies suckle the mother but, at the same time, begin to reduce her food intake. Her milk supply will gradually dry up and the suckling is more for comfort than for food.

Useful tips

■ It is not necessary to remove the bitch from her youngsters altogether; they wean themselves naturally following this system.
■ Cows' milk is not suitable for puppies: it does not have the required nutrient value nor is it sufficiently digestible.
■ Buy a good-quality milk replacer, which is specially formulated for puppies, from the vet or a good pet shop. Within ten days, you should be feeding the puppies six times a day with small amounts of milk replacer.

Feeding the puppies

Typically, feeding should be at four-hourly intervals throughout the day, starting at 8am and finishing at 10pm. Here are some suggestions as to which foods to feed the puppies and when they should be fed during the day.
■ The first meal should be a moist complete puppy food.
■ The second should be crushed boiled egg or scrambled egg.
■ The third should be raw or lightly cooked minced beef, or chicken.
■ For the fourth meal, you can repeat the second meal.
■ For the fifth meal, repeat the third meal and, lastly, at bedtime offer a dish of warm milk.

The mother will gradually become less interested in feeding the pups. The first indications are that she will stand making it difficult for them to reach her. She will also object to the puppies' nails as they massage her teats. The extreme tips of these nails can be cut carefully with scissors to stop them scratching the bitch.

A family of happy Westies.

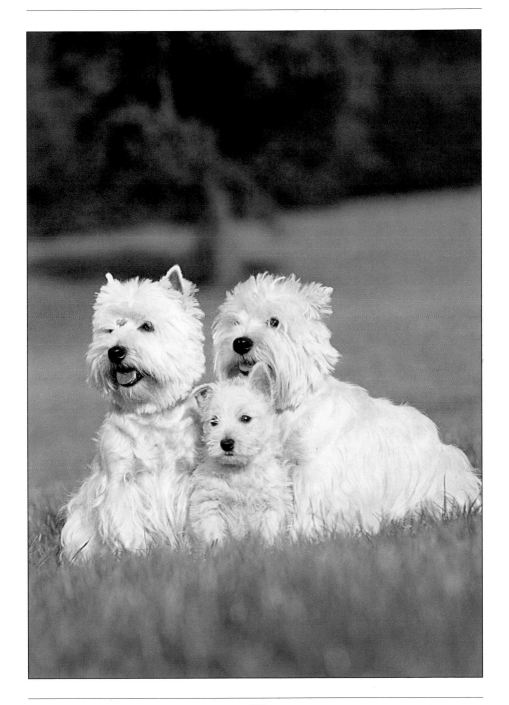

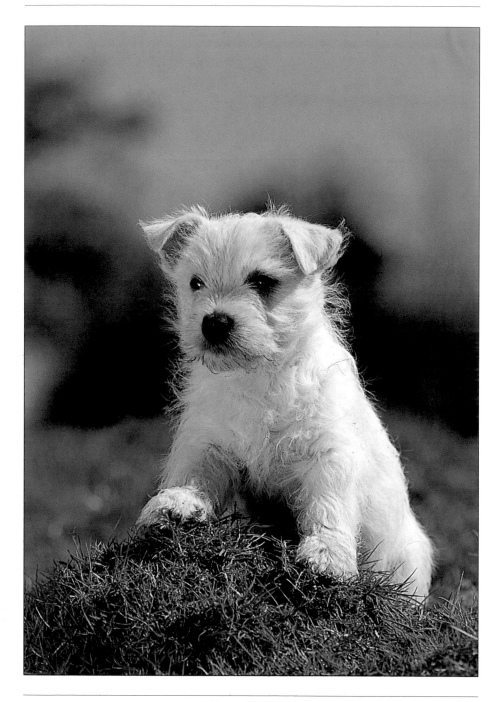

SOCIALIZATION

For the first three weeks there should be no visitors apart from the immediate family because the mother can become stressed and there is an increased risk of infection. Children should not be allowed to handle the puppies until they become bigger and stronger, and even then they should be handled with care. Socialization is of the utmost importance, and the puppies should be subject to as many experiences as possible from an early age, including gentle grooming so that when they get into the big world it will not come as a shock.

Finally, enlist the help of your bitch's breeder to select the best puppy to keep for further breeding or exhibition.

Be careful to find suitable homes for those you cannot keep. You will have gone to considerable trouble to produce really good puppies and it behoves you to find good homes for them. Supply the new owners with a week's supply of food, a diet sheet, Kennel Club papers, insurance and a promise to help in the future if necessary.

Reading through all this and the traps for the unwary, breeding from your dog may not seem worthwhile, but, in truth, the Westic seldom gives

This puppy is imitating his mother; it's all part of the learning process and growing up.

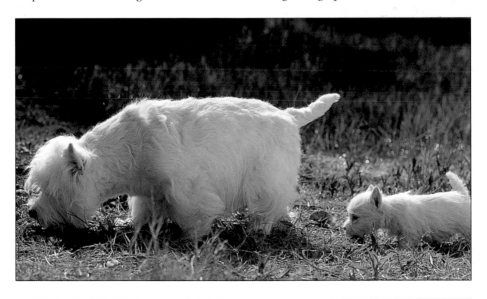

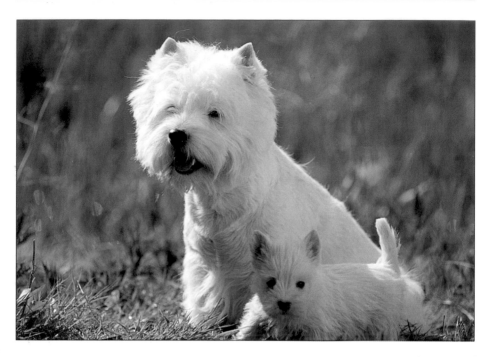

Puppies need to stay with their mother and litter-mates in the all-important first weeks while they are still learning.

any problems and most whelpings are trouble free. At the end of it all, the pure pleasure given by the puppies far outweighs the amount of work and inconvenience involved.

Kennel Club papers

In Great Britain, these are the registration documents that are issued on completion of the form giving the name of the puppy accompanied by the correct fee. When a puppy is sold, the new owner is given the option of transferring

him to his name. He cannot be shown or bred from in the fullness of time unless properly registered and transferred. On completion of the sale, a pedigree of three or four generations is normally handed over.

AFFIX

If you intend to breed more puppies, it is advisable to buy an affix from the Kennel Club. In effect, this is a trade name for the kennel. The Kennel Club tries not to allow similar names, and you can buy their book featuring every affix granted to help you select a suitable name which avoids duplication.

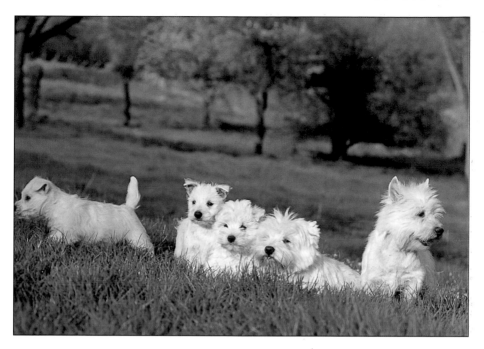

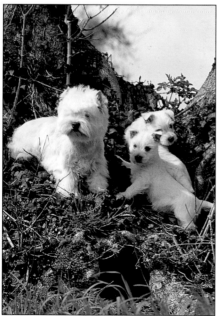

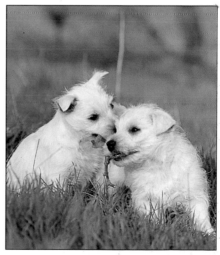

Freedom to play and explore and plenty of games and things to do facilitate the proper development of the puppies.

SHOWING YOUR DOG

THE HISTORY OF DOG SHOWS

Competition between dog owners to select the best working dog or the most beautiful dog really began in Great Britain in 1775 with the showing of fox hounds, and progressed through early agricultural shows, with working sheep dogs, to the towns and cities where urban man, following his agricultural inclinations, used his dogs for `sport', especially killing the rats in the pits of London pubs.

Dog shows, as we know them, began in pubs in the mid-nineteenth century when men would meet at the rat pits to gamble on the expertise of their terriers and afterwards discuss and match their dogs. From these humble beginnings, private organised shows sprang up. Originally, they were staged as profitable commercial enterprises, and the chief among those new nineteenth-century entrepreneurs was Charles Cruft.

Early dog shows

These early shows were not the quiet, well-organised functions we see today – there were few rules and judges were frequently attacked. Competitors resorted to amazing skullduggery because winning dogs could command high prices. 'Ringing dogs' (substituting a winning dog for one that loses) was not unknown, nor was colouring dogs, stealing them and lying about their age and name.

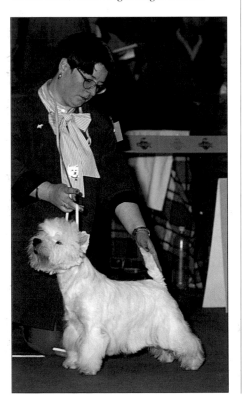

These well-prepared show dogs are in the ring and about to be judged.

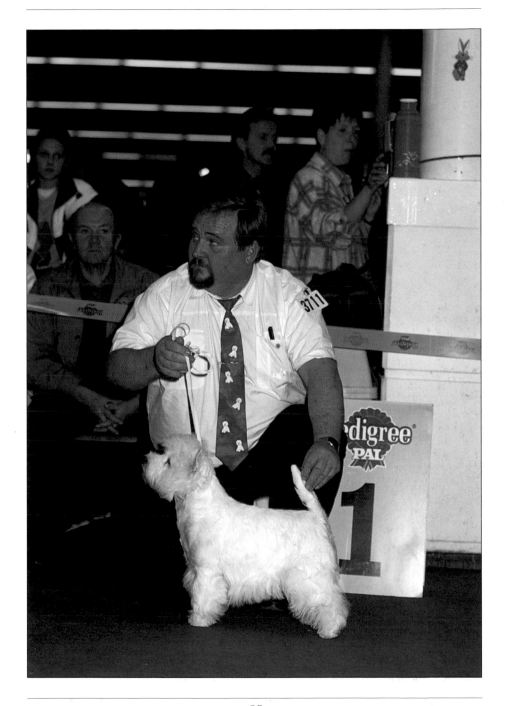

THE KENNEL CLUB

The Kennel Club, founded in Britain in 1873, devised a set of rules to control the criminal element at their own events and to enhance the public perception of dog shows. This was a commercial success, and other show organisers, who were not slow in recognising the benefits, applied to the Kennel Club for permission to impose the same rules. By granting

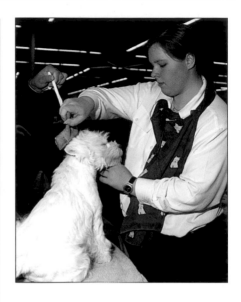

Competition is very fierce at all levels of showing, and last-minute preparation and grooming are all-important.

WARNING

Dog showing can be seriously addictive! It is a fact that many people become so obsessed with showing their dogs that they change their lifestyle, even to the extent of changing their career or moving house in the search for more room and privacy for breeding dogs. There is a whole sub-culture centred around pedigree dogs, controlled by the Kennel Club, which has its own strictly maintained rules, both written and unwritten, and its own language, all of which must be learnt. By careful application, ordinary people can become authorities on their chosen breed. Some move on to judge dogs at high levels, travelling the world to indulge their passion. Social barriers tumble before dog exhibitors and breeders; people from all walks of life mix at dog shows, and unlikely friendships are forged, the love of dogs being the common denominator.

permission, the Kennel Club virtually took over the government of shows throughout the country. When Queen Victoria's dogs were shown, the future of the sport was guaranteed.

Today, the vast majority of dog shows are licensed by the Kennel Club and dogs must be properly registered before they can be entered. The activities of people showing their registered dogs at unlicensed shows are frowned upon severely and can lead to disciplinary action.

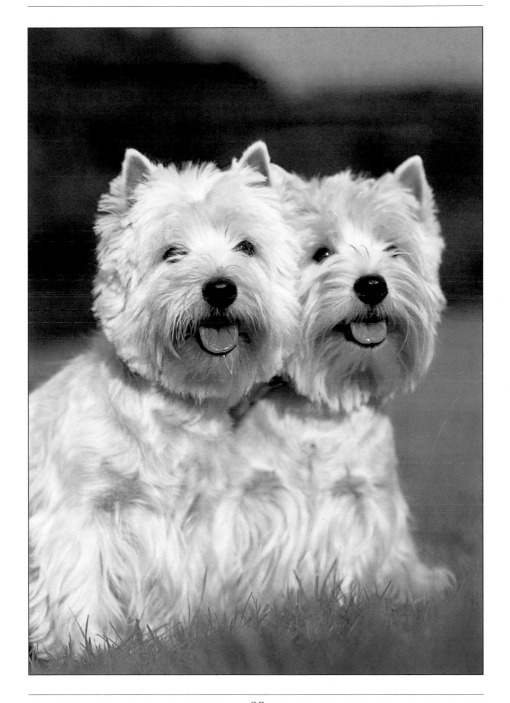

HOW TO START

For up-to-date information on all aspects of pedigree dogs and dog shows, you should purchase one of the specialist weekly newspapers. Their pages are packed with expert advice and comment on show dogs, canine news and current affairs. Every show is advertised in their pages, and each advertisement will publish the name and address of the

'Stacking': holding the dog's head high and pressing the tail into position.

secretary to whom you should apply if you are interested in showing your dog, and who will send a schedule and entry form on request. You may have to send a stamp-addressed envelope.

In the show ring

Not only will you learn the technicalities but you will also teach your dog to enjoy showing. You must teach him to stand still for the examination and how to walk; if the judge cannot see the movement

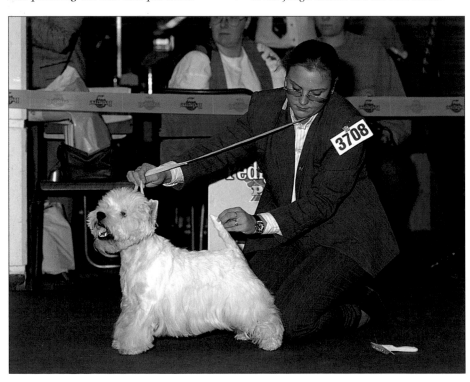

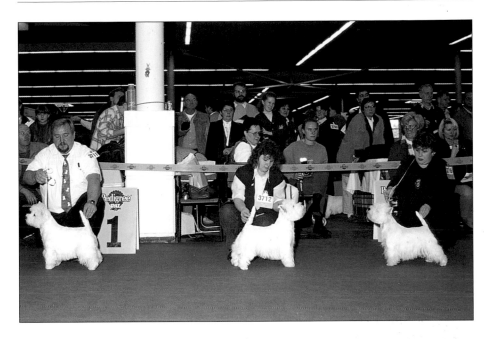

properly he is unlikely to give your dog a placing. It is not simply a question of putting a dog on the lead and walking round the ring. A West Highland White Terrier should walk happily, head held up proudly, with the tail and ears up giving the impression of vivacity. Some dogs show naturally when standing whereas others require stacking, i.e. when the head is held up with the lead and the tail is pressed slightly towards the head.

You have to learn the various patterns that judges may ask you to walk. These may be a straight line, a triangle, a circle, or other more complicated ones which are asked for only rarely. Judges ask you to do this in order to view the dog from all angles. Remember that they

Exhibitors, dogs and their owners, in action at a championship show.

RINGCRAFT

Almost certainly there will be a training club in your vicinity where you and your dog can learn the art of ringcraft – the Kennel Club will supply details. These clubs are the focal point for the novice exhibitor. They are run by people who are experienced in breeding, showing and training all breeds for exhibition, and some will also include obedience and agility training. They usually meet once a week where, for a small fee, anyone can enjoy a pleasant evening in convivial company learning the basics of an absorbing hobby.

This study of a Westie's head illustrates the required pigmentation.

have only a couple of minutes in which to assess each dog so it is entirely up to you to present your Westie in the best possible light.

Learning the ropes

Go to as many shows as possible to study ringcraft, grooming and show presentation. Your friendly breeder will help and advise you, provided that you ask your questions after the show – many competitors are in a state of nerves until they have finished. The ease with which the professional handler shows a dog is deceiving; it comes with practice.

He knows from experience how he can emphasise his dog's good points and minimize the bad points, not only in the ring but also in the trimming.

Ring etiquette

This will be taught at training sessions. There are things that you should never do:
- Never engage the judge in conversation, merely answer his or her questions.
- Nobody should allow their dog to interfere or even disturb another.
- Never argue with a decision – accept all decisions with grace even if you think they're wrong. There will always be another show and another judge and today's placings may be reversed tomorrow. Such is the nature of dog showing.

WARNING

No puppy can be shown before he is six months old. He will finish with puppy classes at twelve months. You must be careful to keep records of your dog's showing prowess. This is because the class in which a dog can be entered is governed by the dog's previous wins. The class definitions appear in the show schedules, and if a dog is entered in a class for which he is ineligible, he will be disqualified and his winnings removed. It is also important that no mistakes are made on the entry form, for the same reason.

SHOW PRESENTATION

Grooming, presentation and condition are of ultimate importance. No judge is going to consider an out-of-condition, miserable dog with a scruffy, unkempt coat. Conditioning a dog involves not only exercising and feeding him properly but also developing his mind. Trimming a harsh-coated terrier for exhibition is an art in itself and quite impossible to describe within the confines of this small book. There are

If you want to show your dog, you will have to invest in a wide range of grooming tools, including brushes and combs, scissors, nail clippers and good stripping knives.

some excellent specialist books on the subject, and you can learn a lot from breeders and observing the winning dogs at major shows.

Tools

When it comes to grooming and trimming your dog, always buy the best tools available, taking advice from established exhibitors. You will need two or three stripping knives, curved bladed scissors, thinning scissors, a steel comb with wide and narrow teeth, a terrier pad (brush), nail clippers and a chalk block. Serious exhibitors will also purchase a grooming table and a grooming stand or restraint. These items, together with

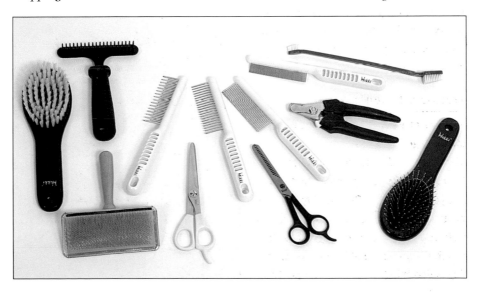

the grooming tools listed above, are sometimes available from good pet stores but can always be obtained from the specialist dealers at the general championship shows and also by mail order, as advertised in the canine press.

Grooming

When the dog is in the rough, i.e. when his coat hasn't been trimmed for several months, it will take between eight and twelve weeks to prepare him for showing. Once the preparation is complete, it is possible to maintain his show coat throughout the duration of the season.

When grooming your Westie, you should always have in your mind's eye a picture of the ideal dog, and all your work should be directed at achieving this objective. Studying photographs of top dogs is also helpful, but there's no substitute for direct observation at the championship shows and discussion with skilled competitors. It takes time and patience to learn how to prepare your dog for showing and master this complex art, but unless a reasonable job is done success will elude you. You must also be sure to give due consideration to the rules of preparation for shows. In Great Britain, these are published in the Rule Book under Rule F(B) and are strictly enforced.

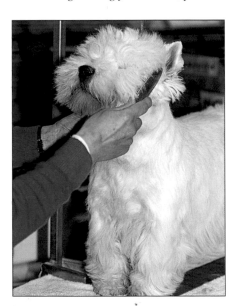

This Westie is being groomed prior to showing. The head is combed to achieve the required shape.

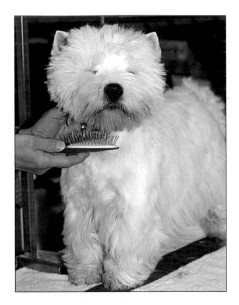

Brushing the dog's 'beard' helps prevent tangling and is essential for show dogs.

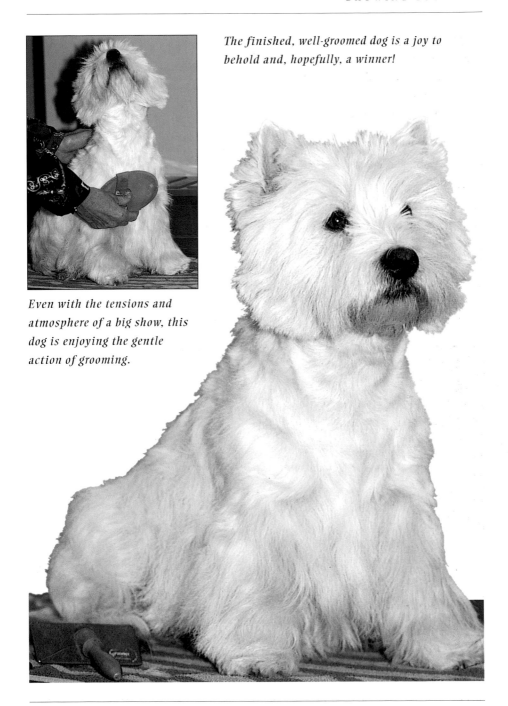

The finished, well-groomed dog is a joy to behold and, hopefully, a winner!

Even with the tensions and atmosphere of a big show, this dog is enjoying the gentle action of grooming.

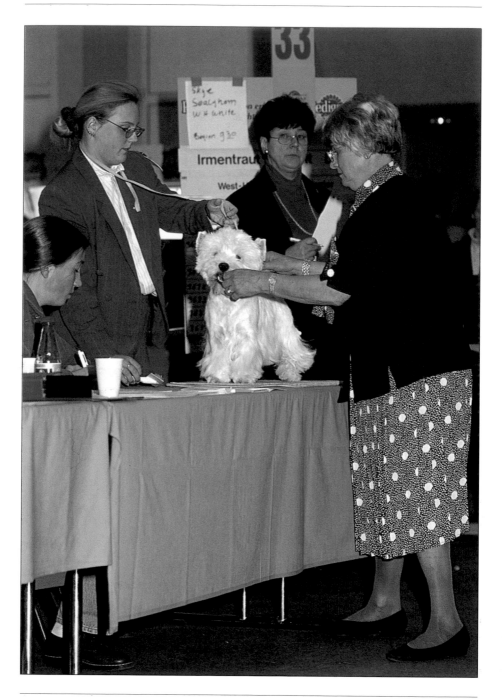

SHOWS

There are several different types of show, and they are all geared to accommodate dogs at different levels of winning.

■ **Matches** These are the lowest level of dog showing, and are held by the training clubs. Entry fees are minuscule and entries are made on the day itself. Two dogs are drawn and matched against each other, the winner going on to the next round with gradual elimination until only one is left.

■ **Exemption shows** These are also at the lower end of the scale. Basically, they are fun events held at minor agricultural shows, garden fetes and the like. Entries are cheap and taken on the field at the show. There are usually four pedigree classes and many fun classes for the family.

■ **Sanction and Limited shows** Both of these have limitations placed on them as to who can enter. However, both shows must be entered and the fees paid prior to the show. The closing dates and the limits are advertised.

■ **Primary shows** These are comparatively new to the showing scene. Entries are made on the day and they are open to everyone. As in the all the previous shows, the dog must not have won anything towards his championship.

■ **Open shows** These are becoming increasingly popular as they are open to all dogs, regardless of winnings. Entries are made before the show and the closing day must be adhered to.

■ **Championship shows** To become a champion, a dog must win three Challenge Certificates under three different judges, and at least one must be won after the dog is twelve months old. The Certificates, also known as 'tickets' or CCs, can be won at specified Championship shows only. There are three categories of Championship shows: the breed club shows; the group shows; and the General Championship shows. They must all be entered and the fees paid several weeks in advance of the shows themselves. Usually, these shows are more expensive to enter than other lesser shows.

SHOWING YOUR DOG

Buying a West Highland White Terrier may lead you into realms about which you've never dreamt. Great careers have been built on the breeding and exhibition of dogs, but this always requires hard work and a total dedication to the breed. As with all animals, there will be sadness and disappointment but the moments of triumph and hours of pleasure will far outweigh anything you have ever experienced – if you've got what it takes.

HEALTHCARE

In this section on healthcare, there is expert
practical advice on keeping your dog healthy
and preventing many common health problems,
together with information on canine illnesses
and diseases and the special health problems that
may affect the breed, especially inherited ones.
If you are considering breeding from your
West Highland White Terrier, you will find
everything that you need to know about genetically
inherited diseases. Essential first-aid techniques for
use in a wide range of common accidents and
emergencies, including road accidents and dog
fights, are also featured, with advice on simple
first-aid measures that you can do yourself, and
when you should seek expert veterinary help.

HEALTH MAINTENANCE

Throughout the health section of this book, where comments relate equally to the dog or the bitch, we have used the term 'he' to avoid the repeated, clumsy use of 'he or she'. Your West Highland White Terrier is definitely not an 'it'.

SIGNS OF A HEALTHY DOG

■ **Appearance and temperament**
In general, a healthy dog looks healthy. He wants to play with you, as games are a very important part of a dog's life. A Westie, being a typical active terrier, should always be ready for his walk, and will require a lot of exercise.

■ **Eyes and nose**
His eyes are bright and alert, and, apart from the small amount of 'sleep' in the inner corners, there is no discharge. His nose is usually cold and wet with no discharge, although a little clear fluid can be normal.

■ **Ears**
His ears are very sharp and responsive to sounds around him. The West Highland White Terrier's ears are short and held erect, which leads to good ventilation of the ear and little ear disease. The inside of his ear flap is pale pink in appearance and silky in texture. No wax will be visible and there will be no unpleasant smell. He will not scratch his ears much, nor shake his head excessively.

■ **Coat**
A healthy West Highland White Terrier's coat will be glossy and feel pleasant to the touch. He will not scratch excessively and scurf will not be present. His coat will smell 'doggy' but not unpleasant, and he will probably shed hairs (moult) continuously, to some degree, especially if he lives indoors with the family.

■ **Teeth**
The teeth of a healthy dog should be white and smooth. If they are yellow and dull, there may be plaque or tartar formation.

■ **Feet and claws**
The claws should not be broken nor too long. There is a short non-sensitive tip, as in our nails. The claws should end at the ground, level with the pad. Dogs will not pay much attention to their feet, apart from normal washing, but excessive licking can indicate disease. Westies have five toes on the front feet, with one in our 'thumb' position called the dew claw, and usually four on the hind feet. If dew claws are present on the hind feet, they are usually removed at three to five days of age, as they become pendulous and are often injured as an adult.

■ **Stools**
A healthy dog will pass stools between once and six times a day depending on diet, temperament, breed and opportunity.

■ **Urination**
A male dog will urinate numerous times on a walk as this is territorial behaviour. Bitches usually urinate less often.

POINTS OF THE WEST HIGHLAND WHITE TERRIER

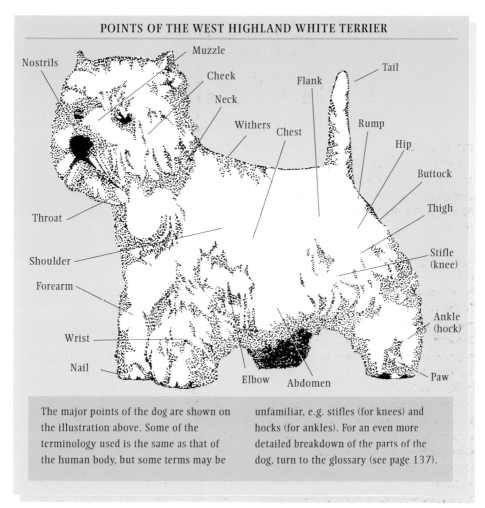

Nostrils
Muzzle
Cheek
Neck
Flank
Tail
Withers
Chest
Rump
Hip
Buttock
Throat
Thigh
Shoulder
Stifle (knee)
Forearm
Wrist
Ankle (hock)
Nail
Elbow
Abdomen
Paw

The major points of the dog are shown on the illustration above. Some of the terminology used is the same as that of the human body, but some terms may be unfamiliar, e.g. stifles (for knees) and hocks (for ankles). For an even more detailed breakdown of the parts of the dog, turn to the glossary (see page 137).

■ Weight

A healthy Westie will look in good bodily condition – not too fat and not too thin. Sixty per cent of dogs nowadays are overweight, so you should try to balance your dog's diet with the right amount of exercise.

■ Feeding

A healthy Westie will usually be ready for his meal and, once adult, he should be fed regularly at the same time each day. Most dogs require one meal a day, but some seem to require two meals daily just to maintain a normal weight. These are the very active dogs who tend to 'burn off' more calories.

DIET

The correct diet as a puppy is essential to allow any dog to achieve his full potential during the growing phase. In a West Highland

EXAMINING YOUR DOG

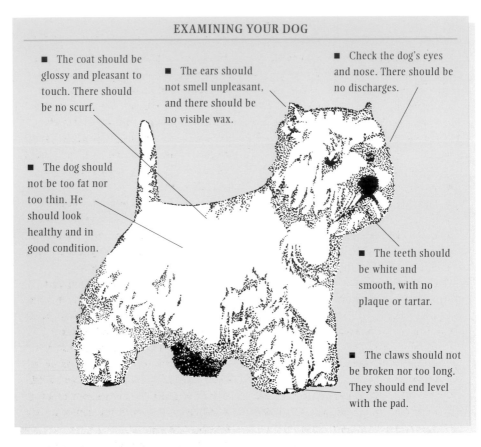

■ The coat should be glossy and pleasant to touch. There should be no scurf.

■ The ears should not smell unpleasant, and there should be no visible wax.

■ Check the dog's eyes and nose. There should be no discharges.

■ The dog should not be too fat nor too thin. He should look healthy and in good condition.

■ The teeth should be white and smooth, with no plaque or tartar.

■ The claws should not be broken nor too long. They should end level with the pad.

White Terrier, this is up to twelve to eighteen months of age. Many home-made diets are deficient in various ingredients just because owners do not fully appreciate the balance that is required. It is far better to rely on one of the correctly formulated and prepared commercial diets, which will contain the right amounts and proportions of essential nutrients, such as protein, carbohydrates, fats, roughage, minerals, such as calcium and phosphorus, and essential vitamins.

■ **Feeding a puppy**

Modern thinking is that the complete, dried, extruded diets, which are now available, have so many advantages that the new puppy could be put on to a growth-formula diet of this type from as early as four weeks of age. Crunchy diets such as these have advantages in dental care also.

Some of the canned and semi-moist diets are excellent although care should be taken to check whether these are complete diets, or complementary foods which require biscuits and other ingredients to be added. Of course, if you really know your diets, it is possible to formulate a nutritious home-prepared diet from fresh ingredients.

He should be fed four times a day until he is

CARE OF THE OLDER DOG

Provided that he has been well cared for throughout his life, there may be no need to treat the older West Highland White Terrier any differently as old age approaches. However, here is some general advice which you may find useful.

■ **Diet**

This should be chosen to:

■ Improve existing problems

■ Slow down or prevent the development of disease

■ Enable the dog to maintain his ideal body weight

■ Be highly palatable and digestible

■ Contain an increased amount of fatty acids, vitamins (especially A, B and E) and certain minerals, notably zinc

■ Contain reduced amounts of protein, phosphorus and sodium

■ **Fitness and exercise**

A healthy West Highland White Terrier should hardly need to reduce his exercise until he is over ten years old. There should be no sudden change in routine; a sudden increase in exercise is as wrong as a sudden drop. Let the dog tell you when he has had enough. If he lags behind, has difficulty in walking, breathing, or getting to his feet after a long walk, then it is time to consider a health check for your Westie. As dogs age, they need a good diet, company, comfort, and a change of scenery to add interest to their lives.

■ **Avoiding obesity**

As the body ages, all body systems age with it. The heart and circulation, lungs, muscles and joints are not as efficient. These should all be able to support and transport a dog of the correct weight but may fail if the dog is grossly overweight.

■ **Diet** A West Highland White Terrier of normal weight will approach old age with a greater likelihood of reaching it. It is wise to diet your dog at this stage if you have let his weight increase. Food intake can be increased almost to normal when the weight loss has been achieved.

■ **Calorie intake and nutrition** Reduce the calorie intake to about sixty per cent of normal, to encourage the conversion of body fat back into energy. Feed a high-fibre diet so that the dog does not feel hungry. Maintenance levels of essential nutrients, such as protein, vitamins and minerals, must be provided so that deficiencies do not occur.

■ **Prescription low-calorie diets**

Alternatively, your veterinary surgeon will be able to supply or advise on the choice of several prescription low-calorie diets, which are available in both dried and canned form, or will instruct you on how to mix your own.

The dog's lifespan

Most people assume that seven years of our lives are equivalent to one year of a dog's. However, a more accurate comparison would be as follows:

■ 1 dog year = 15 human years

■ 3 dog years = 30 human years

■ 6 dog years = 40 human years

■ 9 dog years = 55 human years

■ 12 dog years = 65 human years

■ 15 dog years = 80 human years

Note: This is only an approximate guide as the larger breeds of dog tend not to live as long as the smaller breeds.

three months of age. If a complete dried food is fed, this can be left down so that the puppy can help himself to food whenever he feels hungry. The exact amount of food given will depend on his age and the type of food, and if instructions are not included on the packet, you should consult your vet.

At three months of age, he should be fed three times daily, but each meal should have more in it. By six months of age, the puppy could be reduced to two larger meals a day, but still of a puppy or growth-formula food. Your Westie should remain on this type of food until he is twelve to eighteen months of age, and then should change to an adult maintenance version.

■ **Feeding an adult dog**

Adult dogs can be fed on any one of the excellent range of quality dog foods now available. Your vet is the best person to advise you as to the best diet for your Westie and this advice will vary depending on his age, amount of exercise taken and general health and condition.

■ **Feeding an old dog**

From the age of ten to twelve years onwards, your West Highland White Terrier may benefit

DIET CHECKLIST

■ Feed puppies a special puppy or growth-formula food until they are twelve to eighteen months old
■ Feed adult dogs an adult maintenance version
■ Feed older dogs, over ten to twelve years of age, a specially formulated diet
■ Ask your vet for advice on feeding your dog correctly

from a change to a diet specially formulated for the older dog, as he will have differing requirements as his body organs age a little. Your vet is the best person to discuss this with, as he will be able to assess your dog's general condition and requirements.

EXERCISE

Exercising a puppy

As a puppy, your West Highland White Terrier should not be given too much exercise. At the age at which you acquire him, usually between six and eight weeks old, he will need gentle, frequent forays into your garden, or other people's gardens, provided that they are secure and are not open to stray dogs. He can and should meet other vaccinated, reliable dogs or puppies and play with them. He will also enjoy energetic games with you, but remember that in any tug-of-war type contest you should win!

Although you should be taking him out with you to accustom him to the sights and sounds of normal life, at this stage you should not put him down on the ground in public places until the vaccination course is completed, because of the risk of infection.

About a week after his second vaccination, you will be able to take him out for walks, but remember that at this stage he is equivalent to a toddler. His bones have not calcified, his joints are still developing, and too much strenuous exercise can affect his normal development. Perhaps three walks daily for about half an hour each are ample by about four months of age, rising to two to three hours by the time he reaches six months. At this stage, as his bones and joints develop, he could then be taken for more vigorous runs in

VACCINATIONS

Vaccination is the administration of a modified live or killed form of an infection which does not cause illness in the dog, but instead stimulates the formation of antibodies against the disease itself.

■ **Four major diseases**
There are four major diseases against which all dogs should be vaccinated. These are as follows:

■ Canine distemper (also called hardpad)
■ Infectious canine hepatitis
■ Leptospirosis
■ Canine parvovirus

■ **Kennel cough**
Many vaccination courses now include a component against parainfluenza virus, one of the causes of kennel cough, that scourge of boarding and breeding kennels. A separate vaccine against bordetella, another cause of kennel cough, can be given in droplet form down the nose prior to your dog entering boarding kennels.

Note: All these diseases are described in more detail in Chapter Eight (see page 106).

■ **When to vaccinate**
In the puppy, vaccination should start at eight to ten weeks of age, and is a course of two injections, administered two to four weeks apart.

■ **Adult dogs** are recommended to have an annual check-up and booster inoculation by the vet.

the country or your local park. However, he should not be involved in really tiring exercise until he is nine months to a year old, by which time his joints will have almost fully matured, and his bones will be fully calcified.

Exercising an adult dog

As an adult dog, the Westie's exercise tolerance will be almost limitless, certainly better than most of ours! It is essential that such a lively, active, intelligent breed as the West Highland White Terrier has an adequate amount of exercise daily – it is not really sufficient to provide exercise just at weekends. A daily quota of one to two hours of interesting, energetic exercise is essential.

■ **Games**
During exercise, Westies enjoy playing games, such as retrieving and finding hidden objects, so try to exercise your dog's brain as well as his body.

DAILY CARE

There are several things that you should be carrying out daily for your dog to keep him in first-class condition.

■ **Grooming**
All dogs benefit from a daily grooming. Use a stiff brush or comb, which can be obtained from your vet or pet shop, and ensure that you specify that it is for a West Highland White Terrier as brushes vary considerably. Comb or brush in the direction of the lie of the hair. Hair is constantly growing and being shed, especially in dogs that live indoors with us, as their bodies become confused as to which

season it is in a uniformly warm house. Brushing removes dead hair and scurf, and stimulates the sebaceous glands to produce the natural oils that keep the coat glossy.

■ **Bathing**

Dogs should not require frequent baths, but can benefit from a periodic shampoo using a specially formulated dog shampoo with a conditioner included.

■ **Feeding**

Dogs do not benefit from a frequently changed diet. Their digestive systems become accustomed to a regular diet; dogs do not worry if they have the same food every day (that is a human trait) so you should establish a complete nutritious diet that your dog enjoys, and stick to it.

■ **Feeding times**

The day's food should be given at a regular time each day. Usually the adult dog will have one meal a day, at either breakfast-time or teatime. Both times are equally acceptable but, ideally, hard exercise should not be given within an hour of eating a full meal. It is better to give your dog a long walk and then feed him on your return. Some dogs seem to like two smaller meals a day, and this is perfectly acceptable, provided that the total amount of food given is not excessive.

■ **Water**

Your West Highland White Terrier should have a full bowl of clean, fresh water, which should be changed once or twice a day, and this should be permanently available. This is particularly important if he is on a complete dried food.

■ **Toileting**

Your dog should be let out into the garden first thing in the morning to toilet, and this can be taught quite easily on command and in a specified area of the garden. You should not take him out for a walk just to toilet, unless you just do not have the space at home. The mess should be in your premises and then picked up and flushed down the toilet daily. Other people, children in particular, should not have to put up with our dogs' mess.

■ Throughout the day your Westie should have access to a toileting area every few hours,

TEETH AND JAWS

The molars crush the food whereas the incisors (smaller front teeth) are used for scraping. The large, pointed canine teeth are used for tearing meat.

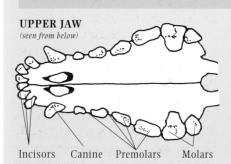

UPPER JAW
(seen from below)

Incisors Canine Premolars Molars

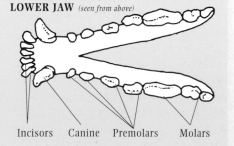

LOWER JAW *(seen from above)*

Incisors Canine Premolars Molars

and always last thing at night before you all go to bed.

■ Dogs will usually want to, and can be conditioned to, defecate immediately after a meal, so this should be encouraged.

■ **Company**

Westies are very sociable dogs and bond to you strongly. There is no point having one unless you intend to be there most of the time. Obviously, a well-trained and socialized adult should be capable of being left for one to three hours at a time, but puppies need constant attention if they are to grow up well balanced. Games, as mentioned before, are an essential daily pastime.

■ **Dental care**

Some complete diets are very crunchy, and by being chewy and mimicking the wild dog's (fox, wolf) diet of a whole rabbit (bones, fur etc.), for instance, you will be able to keep your dog's teeth relatively free of plaque and tartar. However, a daily teeth inspection is sensible. Lift the lips and look at not only the front incisor and canine teeth, but also the back premolars and molars. They should be a healthy, shiny white like ours.

■ **Brushing and diet**

If not, or if your dog is fed a soft, canned or fresh meat diet, daily brushing using a toothbrush and enzyme toothpaste is advisable. Hide chew sticks help clean teeth, as do root vegetables, such as carrots, and many vets recommend a large raw marrow bone. However, these can occasionally cause teeth to break and should be treated with caution. Various manufacturers have brought out tasty, chewy food items that benefit teeth, and your vet will be able to recommend a suitable one for your dog.

■ **Teeth**

Pups are born with, or acquire shortly after

GENERAL INSPECTION

A full inspection of your dog is not necessary on a daily basis, unless you notice something different about him. However, it is as well to cast your eyes over him to ensure that:

■ The coat and skin are in good order
■ The eyes are bright
■ The ears are clean
■ The dog is not lame

Check that he has eaten his food, and that his stools and urine look normal.

birth, a full set of temporary teeth. These start to be shed at about sixteen weeks of age with the central incisors, and the transition from temporary to permanent teeth should be complete by the time your puppy reaches six months of age. If extra teeth seem to be present, or if teeth seem out of position at this age, it is wise to see your vet and ask his advice.

PERIODIC HEALTH CARE

Worming

■ **Roundworms (Toxocara)**

All puppies should be wormed fortnightly from two weeks to three months of age, and then monthly until they are six months old. Thereafter in a male or neutered female West Highland White Terrier, you should worm twice yearly. Dogs used for breeding have special roundworming requirements and you should consult your vet about this. There is evidence that entire females undergoing false (pseudo) pregnancies, have roundworm larvae

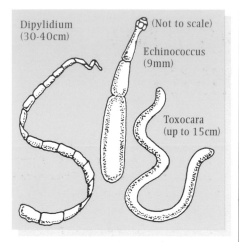

Dipylidium
(30-40cm)

(Not to scale)

Echinococcus
(9mm)

Toxocara
(up to 15cm)

migrating in their tissues, so they should be wormed at this time.

■ **Tapeworms (Dipylidium and Echinococcus)**

These need intermediate hosts (fleas and usually sheep offal respectively) to complete their life cycle, so prevention of contact with these is advisable. As a precaution, most vets recommend tapeworming adult dogs twice every year.

■ **Treatment** There are very effective, safe combined round and tape wormers available now from your vet.

WORMING YOUR DOG

Dogs need to be wormed regularly for roundworms:

■ Fortnightly for puppies from two weeks to three months of age

■ Monthly for puppies from three months to six months of age

■ Twice yearly thereafter in male dogs and neutered females

Adult dogs should be wormed twice a year for tapeworms.

SPECIAL HEALTH PROBLEMS

The West Highland White Terrier is usually a fit, friendly and interesting companion. There are, however, some health problems that are known to occur in this breed particularly. A few of the commoner problems are detailed below.

■ **Perthe's disease**

This is a disease affecting the development of one or both hip joints. It is seen especially in small terriers, and is hereditary in the West Highland White.

■ **Cranio-mandibular osteopathy, or Lion-head disease**

This is inherited in the West Highland White Terrier, and causes bony enlargements in the skull and the mandible.

■ **Atopy**

This is an itchy, allergic skin disease, due to inhaled allergens, which is particularly common in Westies.

■ **Keratoconjunctivitis sicca (KCS)**

Also known as Dry Eye, this is an inherited autoimmune disease and is seen quite commonly in the West Highland White Terrier. It develops when the eye fails to produce tears.

NOTE

In addition to the specific advice given above, you can reduce the chances of your new dog having these problems by asking the right questions about his ancestry before you purchase him. Apart from cranio-mandibular osteopathy, Perthe's disease and atopy, all the above problems are uncommon.

DISEASES AND ILLNESSES

RESPIRATORY DISEASES

■ Rhinitis

This is an infection of the nose, which is caused by viruses, bacteria or fungi. However, it is not very common in the West Highland White Terrier. It may also be part of a disease such as distemper or kennel cough. Sneezing or a clear or coloured discharge are the usual signs of rhinitis. Another cause, due to the dog's habit of sniffing, is a grass seed or other foreign object inhaled through the nostrils. The dog starts to sneeze violently, often after a walk through long grass.

■ Tumours of the nose

These are also occasionally seen in the West Highland White Terrier. The first sign is often haemorrhage from one nostril. X-rays reveal a mass in the nasal chamber.

Diseases producing a cough

A cough is a reflex which clears foreign matter from the bronchi, trachea and larynx. Severe inflammation of these structures will also stimulate the cough reflex.

■ Laryngitis, tracheitis and bronchitis

Inflammation of these structures can be

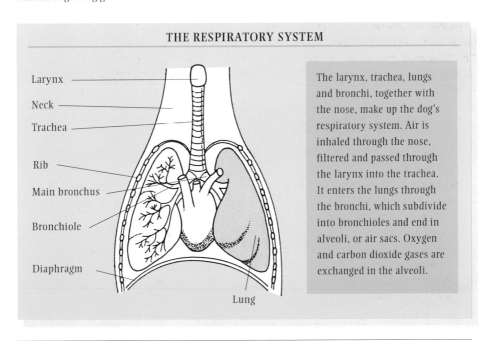

THE RESPIRATORY SYSTEM

Larynx
Neck
Trachea
Rib
Main bronchus
Bronchiole
Diaphragm
Lung

The larynx, trachea, lungs and bronchi, together with the nose, make up the dog's respiratory system. Air is inhaled through the nose, filtered and passed through the larynx into the trachea. It enters the lungs through the bronchi, which subdivide into bronchioles and end in alveoli, or air sacs. Oxygen and carbon dioxide gases are exchanged in the alveoli.

INFECTIOUS DISEASES

- **Distemper (hardpad)**

This is a frequently fatal virus disease which usually affects dogs under one year of age. Affected dogs cough and have a discharge from the eyes and nose. Pneumonia often develops, and vomiting and diarrhoea usually follow. If the dog lives, nervous symptoms, such as fits, paralysis, or chorea (a type of regular twitch), are likely. The pads of the feet become thickened and hard – hence the other name for the disease, hardpad.

Treatment by antibiotics sometimes helps, but the only real answer is prevention by vaccination as a puppy, and then by annual boosters thereafter.

- **Infectious canine hepatitis**

This affects the dog's liver. In severe cases, the first sign may be that a dog goes completely off his food, becomes very depressed and collapses. Some dogs die suddenly. Recovery is unlikely from this severe form of the disease. Prevention by vaccination is essential.

- **Leptospirosis**

Two separate diseases affect dogs. Both, in addition to causing severe and often fatal disease in the dog, are infectious to humans. They are as follows:

- **Leptospira canicola,** which causes acute kidney disease.
- **Leptospira icterohaemorrhagiae,** which causes an acute infection of the liver, often leading to jaundice.

Treatment of both is often unsuccessful, and prevention by vaccination is essential.

- **Canine parvovirus**

This affects the bowels, causing a sudden onset of vomiting and diarrhoea, often with blood, and severe depression. As death is usually due to dehydration, prompt replacement of the fluid and electrolyte loss is essential. In addition, antibiotics are usually given to prevent secondary bacterial infection. Prevention by vaccination is essential.

- **Kennel cough**

This is a highly infectious cough, occurring mainly in kennelled dogs. There are two main causes:

- **Bordetella,** a bacterial infection.
- **Parainfluenza virus**

Both of these affect the trachea and lungs. Occasionally, a purulent discharge from the nose and eyes may develop. Antibiotics and rest are usually prescribed by the vet. Prevention of both by vaccination is recommended.

caused by infection, such as kennel cough or canine distemper, by irritant fumes or by foreign material. Usually, all three parts of the airway are affected at the same time.

Bronchitis is a major problem in the older dog, caused by a persistent infection or irritation, which produces irreversible changes in the bronchi. A cough develops and

increases until the dog seems to cough almost constantly.

Diseases producing laboured breathing

Laboured breathing is normally caused by those diseases that occupy space within the

chest, and reduce the lung tissue available for oxygenation of the blood. An X-ray produces an accurate diagnosis.

■ **Pneumonia**

This is an infection of the lungs. It can occur in the West Highland White Terrier and is caused by viruses, bacteria, fungi or inhaled matter, such as water.

■ **Chest tumours**

These can cause respiratory problems by occupying lung space and by causing the accumulation of fluid within the chest.

Accidents

Respiratory failure commonly follows accidents. Several types of injury may be seen, including:

■ **Haemorrhage into the lung**

Rupture of a blood vessel in the lung will release blood which fills the air sacs.

■ **Ruptured diaphragm** allows abdominal organs, such as the liver, spleen or stomach, to move forwards into the chest cavity.

HEART AND CIRCULATION DISEASES

Heart attack in the human sense is uncommon. Collapse or fainting may occur due to inadequate cardiac function.

Heart murmurs

■ **Acquired disease**

This may result from wear and tear or inflammation of heart valves, problems of rhythm and rate, or disease of the heart muscle. Signs of disease may include:

■ Weakness
■ Lethargy
■ Panting

SECTION OF THE HEART

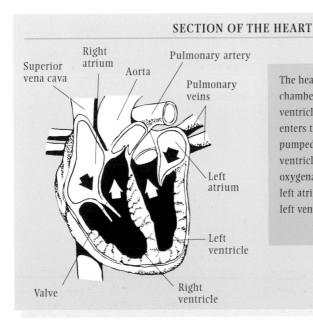

The heart consists of two pairs of chambers: the atria and the ventricles. Deoxygenated blood enters the right atrium and is pumped out through the right ventricle to the lungs where it is oxygenated. This blood flows into the left atrium and thence through the left ventricle to the body's organs.

THE CIRCULATORY SYSTEM

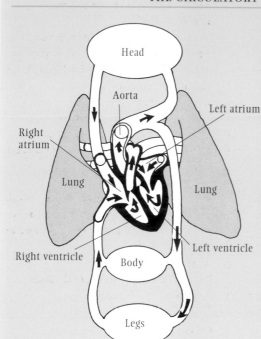

Head

Aorta

Left atrium

Right atrium

Lung

Lung

Right ventricle

Body

Left ventricle

Legs

Blood circulates around the dog's body by way of the circulatory system.

■ Oxygenated blood is pumped by the heart through the arteries to all the body organs, e.g. the brain, muscles and liver.

■ Oxygen and nutrients are extracted from the blood.

■ The used blood is returned by the veins to the right ventricle and then to the lungs.

■ In the lungs, carbon dioxide is exchanged for oxygen.

■ Coughing
■ Abdominal distension
■ Collapse
■ Weight loss

Congenital heart disease

This is usually due to valve defects or a hole in the heart. Both are seen fairly frequently in the West Highland White Terrier. Signs of disease may include:

■ Weakness and failure to thrive or grow at a normal rate

■ The sudden death of a puppy

Note: congestive heart failure is the end result of any of these defects.

Signs of heart failure

■ Exercise intolerance
■ Lethargy
■ Panting and/or cough
■ Enlargement of the abdomen due to fluid accumulation
■ Poor digestion and weight loss

Note: Veterinary investigation involves thorough examination, possibly X-rays of the chest, ECG, and, in some cases, ultrasound scanning.

Heart block

This is an acquired problem. A nerve impulse

conduction failure occurs in the specialized heart muscle, which is responsible for maintaining normal rhythm and rate.

Blood clotting defects

- **Clotting problems**

These may result from poisoning with Warfarin rat poison. Haemorrhage then occurs which requires immediate treatment (see first aid, page 129).

- **Congenital clotting defects**

These arise in the West Highland White Terrier if the pup is born with abnormal blood platelets or clotting factors, both of which are essential in normal clotting.

Tumours

The spleen, which is a reservoir for blood, is a relatively common site for tumours, especially in older dogs. Splenic tumours can bleed slowly into the abdomen or rupture suddenly, causing collapse. Surgical removal of the spleen is necessary.

DIGESTIVE SYSTEM DISEASES

Mouth problems

Dental disease

- **Dental tartar**

This forms on the tooth surfaces when left-over food (plaque) solidifies on the teeth. This irritates the adjacent gum, causing pain, mouth odour, gum recession, and, ultimately, tooth loss. This inevitable progression to periodontal disease may be prevented if plaque is removed by regular tooth brushing with a specially formulated tooth paste for dogs, coupled with good diet, large chews and hard biscuits.

- **Periodontal disease**

This disease, or inflammation and erosion of the gums around the tooth roots, is very common. Careful scaling and polishing of the dog's teeth by your vet under an anaesthetic is necessary to save the teeth.

- **Dental caries (tooth decay)**

This is common in people, but not so in dogs *unless they are given chocolate and other sweet foods.*

- **Tooth fractures**

These can result from trauma in road accidents or if your dog is an enthusiastic stone catcher or chewer. A root treatment may be needed to treat them effectively.

- **Epulis**

This is a benign overgrowth of the gum. Surgical removal is needed.

Salivary cysts

These may occur as soft, fluid-filled swellings under the tongue or neck, resulting from a ruptured salivary duct.

Mouth tumours

These are often highly malignant, growing rapidly and spreading to other organs. First symptoms may be:

- Bad breath
- Increased salivation
- Bleeding from the mouth
- Difficulties in eating

Cranio-mandibular osteopathy (or Lion-head disease)

(see bone diseases, page 122)

THE DIGESTIVE SYSTEM

The mouth, throat, oesophagus, stomach, intestines, liver and pancreas together make up the digestive system. When food is swallowed, it passes through the oesophagus into the stomach and intestines where it is broken down by enzymes. Nutrients are absorbed by the body, and waste matter is eliminated via the rectum.

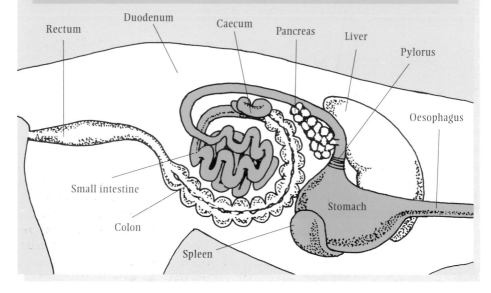

Rectum · Duodenum · Caecum · Pancreas · Liver · Pylorus · Oesophagus · Anus · Small intestine · Colon · Spleen · Stomach

Foreign bodies in the mouth

(see first aid section, page 134)

Problems causing vomiting

■ Gastritis

This is inflammation of the stomach and can result from unsuitable diet, scavenging or infection. The dog repeatedly vomits either food or yellowish fluid and froth, which may be blood stained.

■ Obstruction of the oesophagus

This leads to regurgitation of food immediately after feeding, and may be caused by small bones or other foreign bodies. Diagnosis is confirmed by X-ray or examination with an endoscope, and treatment must not be delayed.

■ Obstruction lower down the gut, in the stomach or intestine

This may result from items such as stones, corks etc. Tumours can also lead to obstructive vomiting. The dog rapidly becomes very ill and the diagnosis is usually confirmed by palpation, X-rays or exploratory surgery.

■ Intussusception

This is telescoping of the bowel, which can follow diarrhoea, especially in puppies. Surgery is essential.

PROBLEMS CAUSING DIARRHOEA

■ **Dietary diarrhoea**

This can occur as a result of sudden changes in diet, scavenging, feeding unsuitable foods or stress (especially in puppies when they go to their new home).

■ **Pancreatic insufficiency** (see below)

■ **Enteritis**

This is inflammation of the small intestines which can be caused by infection, e.g. parvovirus, a severe worm burden or food poisoning. Continued diarrhoea leads to dehydration.

■ **Colitis**

This is inflammation of the large bowel (colon), and symptoms include straining and frequent defecation, watery faeces with mucous or blood, and often an otherwise healthy dog.

■ **Tumours of the bowel**

Tumours of the bowel are more likely to cause vomiting than diarrhoea, but one called lymphosarcoma causes diffuse thickening of the gut lining, which may lead to diarrhoea.

■ **Gastric dilation**

(see first aid section, page 135)

■ **Megoesophagus**

This is a defect in the wall of the oesophagus due to faulty nerve control, which leads to ballooning, retention of swallowed food and regurgitation before the food reaches the stomach.

Pancreatic diseases

■ **Acute pancreatitis**

This is an extremely painful and serious condition requiring intensive therapy. It can be life-threatening.

■ **Pancreatic insufficiency**

Wasting of the cells of the pancreas produces digestive enzymes and leads to poor digestive function, persistent diarrhoea, weight loss and ravenous appetite. The condition, when it occurs, is often diagnosed in dogs of less than two years of age, and is seen occasionally in the West Highland White Terrier. Diagnosis is made on clinical symptoms and laboratory testing of blood and faeces.

■ **Diabetes mellitus (sugar diabetes)**

Another function of the pancreas is to manufacture the hormone insulin, which controls blood sugar levels. If insulin is deficient, blood and urine glucose levels rise, both of which can be detected on laboratory testing. Affected animals have an increased appetite and thirst, weight loss and lethargy. If left untreated, the dog may go into a diabetic coma.

■ **Pancreatic tumours**

These are relatively common and are usually highly malignant. Symptoms vary from vomiting, weight loss and signs of abdominal pain to acute jaundice. The prognosis is usually hopeless, and death occurs rapidly.

Liver diseases

■ **Acute hepatitis**

Infectious canine hepatitis and leptospirosis (see infectious diseases, page 106). These diseases are not common as most dogs are vaccinated against them.

■ **Chronic liver failure**

This can be due to heart failure, tumours or cirrhosis. Affected dogs usually lose weight

and become depressed, go off their food and may vomit. Diarrhoea and increased thirst are other possible symptoms. The liver may increase or decrease in size, and there is sometimes fluid retention in the abdomen. Jaundice is sometimes apparent. Diagnosis of liver disease depends on symptoms, blood tests, X-rays or ultrasound examination, and possibly liver biopsy.

SKIN DISEASES

Itchy skin diseases

Parasites

■ **Fleas** are the commonest cause of skin disease, and dogs often become allergic to them. They are dark, fast-moving, sideways-flattened insects, about two millimetres long.

STRUCTURE OF THE SKIN

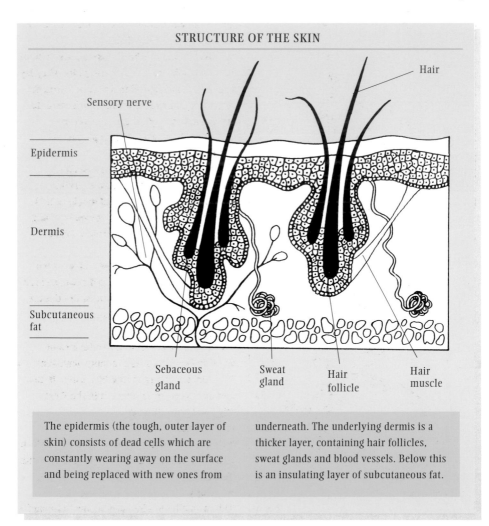

Sensory nerve

Hair

Epidermis

Dermis

Subcutaneous fat

Sebaceous gland

Sweat gland

Hair follicle

Hair muscle

The epidermis (the tough, outer layer of skin) consists of dead cells which are constantly wearing away on the surface and being replaced with new ones from underneath. The underlying dermis is a thicker layer, containing hair follicles, sweat glands and blood vessels. Below this is an insulating layer of subcutaneous fat.

PARASITES

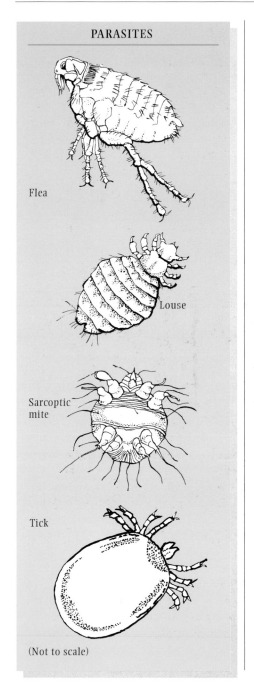

Flea

Louse

Sarcoptic mite

Tick

(Not to scale)

They spend about two hours a day feeding on the dog, then jump off and spend the rest of the day breeding and laying eggs. They live for about three weeks and can lay fifty eggs a day. Thus each flea may leave behind 1,000 eggs which hatch out in as little as three weeks. It is important to treat the dog with an effective, modern veterinary product, as well as the environment, i.e. the dog's basket and bedding, and other areas in the house. Ask your vet for advice on which is the best product to use, i.e. sprays, washes or powders.

■ **Lice** are small, whitish insects, which crawl very slowly between and up the hairs. They lay eggs on the hair, spend their entire life on the dog and are less common and much easier to treat than fleas. Again, ask your vet to recommend a parasiticidal preparation for killing lice.

■ **Mange** is caused by mites (usually Sarcoptes), which burrow into the skin, causing intense irritation and hair loss. It is very contagious and more common in young dogs. Treatment is by antiparasitic washes.

■ **Bacterial infections**

These are common in the dog and are often secondary to some other skin disease, such as mange or allergies. Long-term antibiotics are needed to control some skin diseases.

■ **Pyoderma**

This can be an acute, wet, painful area of the skin (wet eczema), or a more persistent infection appearing as ring-like, sores. Both conditions are quite common in the West Highland White Terrier.

■ **Furunculosis**

This is a deeper, more serious infection, which is seen quite often in the West Highland White Terrier.

■ **Atopy**

This is an allergic skin disease due to inhaled

allergens. It results in a recurrent or continuous, severely itchy skin disease and is particularly common in Westies. It can start as early as six months of age and is commonly due to inhalation of pollen, house dust, or house dust mites. Intradermal skin tests by your vet can ascertain the precise cause.

- **Contact dermatitis**

This is an itchy reddening of the skin, usually of the abdomen, groin, armpit, or feet, where the hair is thinnest and less protective. It can be an allergic response to materials, such as wool, nylon, or carpets, or to a direct irritant, such as oil, or a disinfectant.

- **Lick granuloma**

This is a thickened, hairless patch of skin, which is usually seen on the front of the wrist or the side of the ankle. It is seen in the West Highland White Terrier and is thought to result from constant licking of this area because of boredom or neurosis.

Non-itchy skin diseases

- **Demodectic mange**

Caused by a congenitally-transmitted parasitic mite, demodectic mange is seen usually in growing dogs, and causes non-itchy patchy hair loss.

- **Ticks**

These are parasitic spiders resembling small grey peas that attach themselves to the skin. They drop off after a week, but should be removed when noticed. Soak them with surgical spirit and pull them out using fine tweezers. You can prevent tick infestation by using a parasiticide on the dog before exercising him in the woods or countryside.

- **Ringworm**

This is a fungal infection of the hairs and skin causing bald patches. It is transmissible to

TUMOURS AND CYSTS

- **Sebaceous cysts**

These are round, painless nodules in the skin and vary from 2 mm up to 4 cm in diameter. They are sometimes seen in West Highland White Terriers, particularly as they get older.

- **Warts**

These may be seen in the older West Highland White Terrier. Other skin tumours do occur.

- **Anal adenomas**

These frequently develop around the anus in old male dogs. They ulcerate when they are quite small and produce small bleeding points.

man, especially children. Wear rubber gloves when handling a dog with ringworm. The infected hair should be removed and the skin cleansed with a fungicidal wash. Consult your vet for advice on treatment.

- **Hormonal skin disease**

This patchy, symmetrical hair loss is not common in the West Highland White Terrier.

DISEASES OF THE ANAL AREA

- **Anal sac impaction** can occur in the West Highland White Terrier. The anal sacs are scent glands and are little used in the dog. If the secretion accumulates in the gland instead of being emptied during defecation as the dog raises his tail, the overfull anal sac become itchy. The dog drags his anus along the ground or bites himself around the base of his tail. Unless the sacs are emptied by your vet, an abscess may form.

STRUCTURE OF THE FOOT

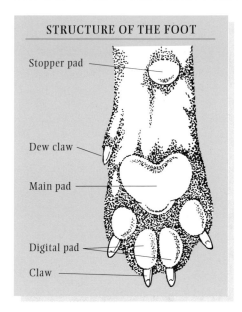

Stopper pad

Dew claw

Main pad

Digital pad

Claw

DISEASES OF THE FEET

■ **Interdigital eczema**
Westies seem to lick their feet readily after minor damage, and this makes the feet very wet. Infection then occurs between the pads.

■ **Interdigital cysts and abscesses**
These are painful swellings between the toes which may make the dog lame. In most cases, the cause is unknown, but they can be caused by a grass seed penetrating the skin between the toes.

■ **Foreign body in the pad**
The most common foreign body to become lodged in the pads is a sharp fragment of glass, or a thorn. The dog is usually very lame and the affected pad is painful to the touch. Often an entry point will be seen on the pad.

■ **Nail bed infections**
With these infections, the toe becomes swollen and painful and the dog becomes lame. The bone may become diseased and this can lead to amputation of the affected toe.

EAR DISEASES

Haematoma

This is a painless, sometimes large, blood blister in the ear flap, which is usually caused by head shaking due to an ear infection or irritation. Haematomas are not common in the West Highland White Terrier, but if they occur, surgery is usually necessary.

Infection (otitis)

As he has a short, pricked-up ear, which is well ventilated, the West Highland White Terrier is not prone to ear infections. When otitis occurs, a smelly discharge appears, and the dog shakes his head or scratches his ear. If the inner ear is affected, the dog may also show a head tilt or a disturbance in his balance.

■ **Treatment** with antibiotic ear drops is usually successful, but sometimes syringing or a surgical operation is needed. The vet must be consulted as there are several possible reasons for ear disease, including ear mites and grass seeds.

STRUCTURE OF THE EAR

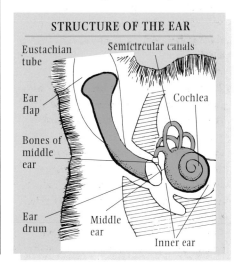

Eustachian tube

Semicircular canals

Ear flap

Cochlea

Bones of middle ear

Ear drum

Middle ear

Inner ear

EYE DISEASES

Entropion

This is an inherited disease, which is rare in the West Highland White Terrier. The edge of an eyelid rolls inwards so that the lashes rub against the surface of the eye, causing irritation of the eyeball. The eye is sore and wet with tears, and often kept closed. You must consult your vet as surgical treatment is necessary.

Third eyelid disease

This is usually a prolapse of the Harderian gland, which is a small fleshy mass of tissue behind the third eyelid. It can become displaced and protrude. Surgical removal is necessary.

Prolapse of the eye

(see first aid, page 134)

Conjunctivitis

This occurs in the West Highland White Terrier. The white of the eye appears red and discharges. Possible causes include viruses, bacteria, chemicals, allergies, trauma or foreign bodies.

Keratitis

This is a very sore inflammation of the cornea which may appear blue and lose its shiny appearance.

Keratoconjunctivitis sicca (KCS)

Also known as Dry Eye, this is an inherited autoimmune disease and is seen quite commonly in the West Highland White Terrier. It develops when the eye fails to produce tears. The cornea dries, keratitis develops, and the eye discharges a greyish sticky mucus. In time, the cornea is invaded

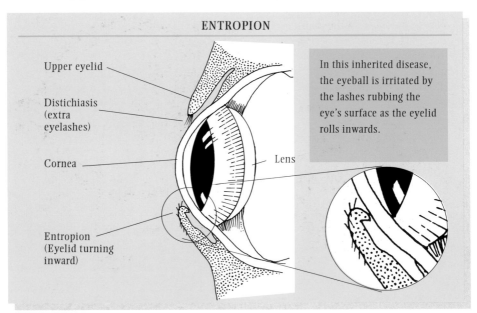

ENTROPION

Upper eyelid

Distichiasis (extra eyelashes)

Cornea

Lens

Entropion (Eyelid turning inward)

In this inherited disease, the eyeball is irritated by the lashes rubbing the eye's surface as the eyelid rolls inwards.

by blood vessels which cause pigmentation and loss of sight. One or both eyes can be affected. Medical treatment can control the disease in the early stages, but KCS can cause severe loss of vision and pain.

Pannus

This is an autoimmune inflammation of the cornea. It occurs in some older West Highland White Terriers.

Corneal ulcer

This is an erosion of part of the surface of the cornea and can follow an injury or keratitis,

and is very painful. The dog will hardly be able to open his eye which will flood with tears.

Glaucoma

This develops when the pressure of the fluid inside the eye increases. As the pressure increases, the eye becomes painful, inflamed, and excessive tear production occurs.

Cataract

This is an opacity of the lens in one or both eyes. The pupil appears greyish instead of the normal black colour. In advanced cases, the lens looks like a pearl and the dog may be

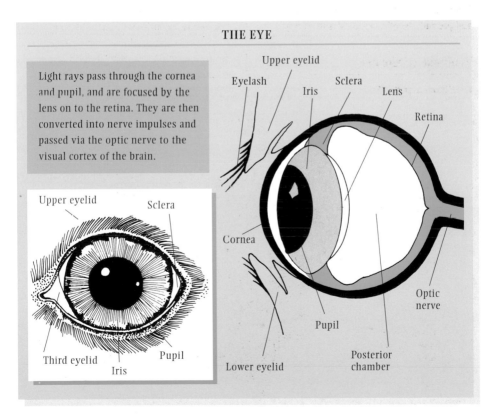

THE EYE

Light rays pass through the cornea and pupil, and are focused by the lens on to the retina. They are then converted into nerve impulses and passed via the optic nerve to the visual cortex of the brain.

Upper eyelid
Sclera
Eyelash
Iris
Lens
Retina
Cornea
Optic nerve
Pupil
Posterior chamber
Lower eyelid

Upper eyelid
Sclera
Third eyelid
Pupil
Iris

blind. The causes of cataract in West Highland White Terriers include infection, diabetes mellitus and trauma.

URINARY SYSTEM DISEASES

Diseases producing increased thirst

- **Acute kidney failure**

The most common infectious agent producing acute nephritis is Leptospirosis (see infectious diseases, page 106).

- **Chronic kidney failure**

This is common in old dogs and occurs when persistent damage to the kidney results in toxic substances starting to accumulate in the blood stream.

Diseases causing blood in the urine

- **Cystitis**

This is an infection of the bladder. It is more common in the bitch than in the dog because the infection has easy access through the shorter urethra. The clinical signs include:

- Frequency of urination
- Straining
- Sometimes a bloody urine

In all other respects the dog remains healthy.

- **Urinary calculi or stones**

These can form in either the kidney or the bladder.

- **Kidney stones** are small stones which can enter the ureters causing the dog severe abdominal pain.

- **Bladder stones,** or calculi, are fairly common in both sexes. In the bitch, they are larger and straining is usually the only clinical sign. In the dog, the most common sign is unproductive straining due to urinary obstruction. This is an acute emergency.

- **Tumours of the bladder**

These can occur and cause frequent straining and bloody urine or, by occupying space within the bladder, cause incontinence.

- **Incontinence**

This occurs occasionally for no apparent reason, especially in the older bitch. Hormones, or medicine to tighten the bladder sphincter, can help.

REPRODUCTIVE ORGAN DISEASES

The male dog

- **Retained testicle (cryptorchidism)**

Occasionally one or both testicles may fail to descend into the scrotum and remain somewhere along their developmental path in the abdomen or groin. Surgery is advisable to remove retained testicles as they are very likely to develop cancer.

- **Tumours**

These are relatively common but, fortunately, most are benign. One type of testicular tumour, known as a Sertoli cell tumour, produces female hormones leading to the development of female characteristics.

- **Prostate disease**

This occurs in the older West Highland White Terrier, usually a benign enlargement where the prostate slowly increases in size. Hormone treatment or castration helps.

- **Infection of the penis and sheath (balanitis)**

An increase and discolouration occurs in the discharge from the sheath, and the dog licks his penis more frequently.

- **Paraphimosis,** or prolapse of the penis (see first aid, page 136).

- **Castration**

THE MALE: URINARY SYSTEM

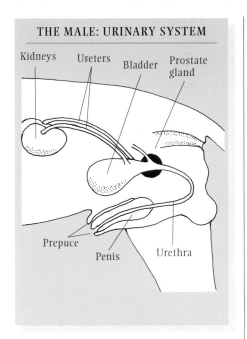

Kidneys Ureters Bladder Prostate gland

Prepuce Penis Urethra

THE BITCH: URINARY SYSTEM

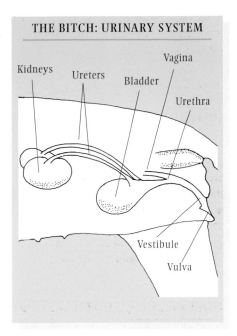

Kidneys Ureters Bladder Vagina Urethra

Vestibule Vulva

This is of value in the treatment of behavioural problems. Excessive sexual activity, such as mounting cushions or other dogs, and territorial urination may be eliminated by castration, as may certain types of aggression and the desire to escape and wander.

The bitch

■ **Pyometra**

This uterine infection is a common and serious disease of the older bitch, although bitches which have had puppies seem less likely to develop it. The treatment of choice is usually an ovariohysterectomy.

■ **Mastitis**

This is an infection of the mammary glands and occurs usually in lactating bitches. The affected glands become swollen, hard and painful (see breeding, page 74).

■ **False or pseudo-pregnancy**

This occurs in most bitches about eight to twelve weeks after oestrus at the stage when the bitch would be lactating had she been pregnant. The signs vary and include:

■ Poor appetite
■ Lethargy
■ Milk production
■ Nest building
■ Aggressiveness
■ Attachment to a substitute puppy which is often a squeaky toy

Note: Once a bitch has had a false pregnancy, she is likely to have one after each heat period.

■ **Treatment,** if needed, is by hormones, and prevention is by a hormone injection, or tablets, and long-term by spaying (an ovariohysterectomy).

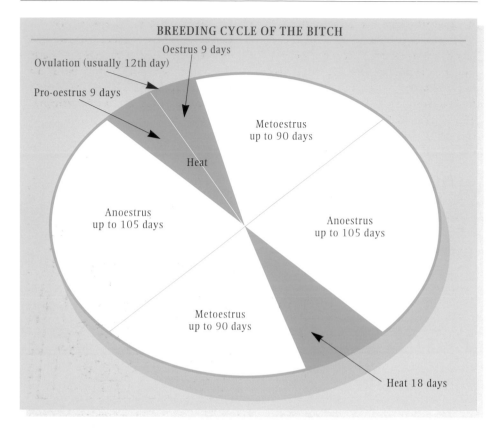

BREEDING CYCLE OF THE BITCH

Oestrus 9 days

Ovulation (usually 12th day)

Pro-oestrus 9 days

Metoestrus up to 90 days

Heat

Anoestrus up to 105 days

Anoestrus up to 105 days

Metoestrus up to 90 days

Heat 18 days

BIRTH CONTROL

■ Hormone therapy

Several preparations, injections and tablets, are available to prevent or postpone the bitch's heat period.

■ Spaying (ovariohysterectomy)

This is an operation to remove the uterus and ovaries, usually performed when the bitch is not on heat.

NERVOUS SYSTEM DISEASES

The nervous system consists of two parts:

1 **The central nervous system (CNS)**
The brain and the spinal cord which runs through the vertebral column of the dog.

2 **The peripheral nervous system** All the nerves that connect the CNS to the organs of the body.

■ Canine distemper virus

(see infectious diseases, page 106)

■ Vestibular syndrome

This is a fairly common condition of the older dog, and affects that part of the brain that controls balance. There is a sudden head tilt to the affected side, often flicking movements of the eyes called nystagmus, and the dog may fall or circle to that side. Many dogs will recover slowly but the condition may recur.

■ **Slugbait (Metaldehyde) poisoning**
The dog appears 'drunk', uncoordinated, and may have convulsions. There is no specific treatment for this condition, but sedation may lead to recovery.

■ **Epilepsy**
This is a nervous disorder causing fits.

The dog has a sudden, unexpected fit or convulsion, which lasts for about two minutes. Recovery is fairly quick, although the dog may be dull and look confused for a few hours. Treatment is usually necessary and successful as far as control of epilepsy is concerned.

THE REPRODUCTIVE SYSTEM

The dog
Sperm and testosterone are produced in the male dog's testicles. Sperm pass into the epididymis for storage and thence via the vas deferens during mating.

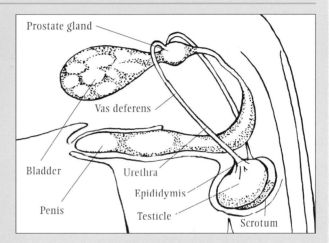

Prostate gland

Vas deferens

Bladder

Urethra

Epididymis

Penis

Testicle

Scrotum

The bitch
Eggs are produced in the ovaries and enter the uterus through the fallopian tubes. During the heat period, they can be fertilized by sperm.

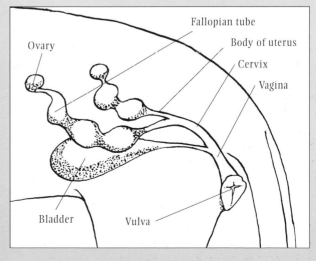

Fallopian tube

Body of uterus

Ovary

Cervix

Vagina

Bladder

Vulva

BONE, MUSCLE AND JOINT DISEASES

X rays are necessary to confirm any diagnosis involving bone.

Bone infection (osteomyelitis)

This usually occurs after an injury such as a bite, or where a broken bone protrudes through the skin. Signs are pain, heat and swelling over the site, and if a limb bone is affected, there can be severe lameness.

- **Perthe's disease**

This is a disease affecting the development of one or both hip joints. It is seen especially in small terriers, and is hereditary in the West Highland White. The bone of the head of the femur degenerates, producing severe pain and collapse of the joint. Failure of the blood

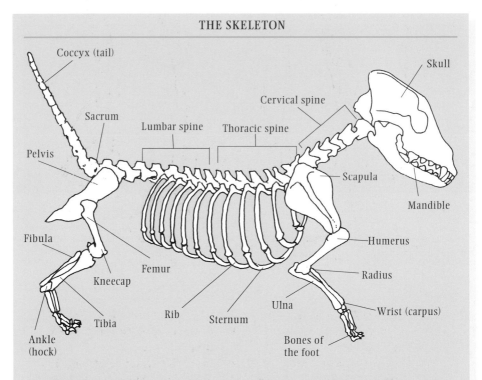

THE SKELETON

Coccyx (tail)

Skull

Cervical spine

Sacrum

Lumbar spine

Thoracic spine

Pelvis

Scapula

Mandible

Fibula

Humerus

Kneecap

Femur

Radius

Ulna

Rib

Sternum

Wrist (carpus)

Tibia

Ankle (hock)

Bones of the foot

The skeleton is the framework for the body. All the dog's ligaments, muscles and tendons are attached to the bones, 319 of them in total. By a process called ossification, cartilage template is calcified to produce bone. Bones are living tissue and they respond to stresses and strains. To build and keep healthy bones, West Highland White Terriers need a nutritionally balanced diet which contains an adequate supply of calcium, vitamin D and phosphorus.

TYPES OF FRACTURES

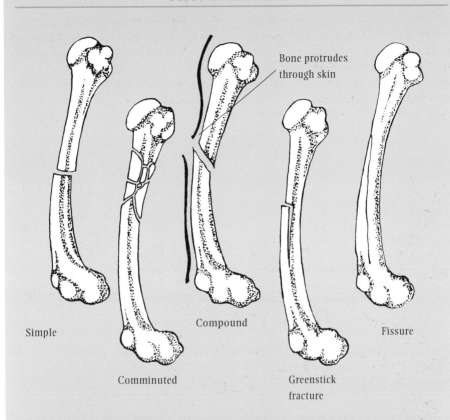

Bone protrudes through skin

Simple

Comminuted

Compound

Greenstick fracture

Fissure

Any break or crack in a bone is called a fracture. When a vet repairs a fracture, his aim is to replace the fractured ends of bone into their normal position and then to immobilize the bone for four to six weeks. Depending on the bone, and type of fracture, there are several methods available – cage rest, external casts, or surgery to perform internal fixation, by, for example, plating or pinning.

Five types of fracture are shown above:
- **Simple fracture:** the bone is broken into two pieces at one site
- **Comminuted fracture:** the bone is broken into several pieces
- **Compound fracture:** the skin is penetrated by a broken bone end
- **Greenstick fracture:** the break is incomplete with part of the bone remaining intact
- **Fissure:** the bone is cracked

supply to this small piece of bone is thought to be the cause.

■ **Cranio-mandibular osteopathy (or Lion-head disease)**

This is an uncommon disease, almost always seen in the young, growing West Highland White and Scottish Terriers. Bony enlargements develop on the skull and the mandible of the lower jaw. The disease is painful in the early stages, and the puppy will have a temperature, be reluctant to eat, and salivate excessively.

There is no specific treatment but during the active phase the pain can be controlled with pain-killing drugs. The disease is self-limiting and when the dog is fully grown at about nine months of age, no more new bone is produced. The dog is then left with painless, bony lumps on the skull and jaw.

■ **Bone tumours**

These are not common in the West Highland White Terrier.

■ **Sprains**

A sprain is an inflammation of an over-stretched joint. The joint is hot, swollen and painful, and the dog is lame.

■ **Cruciate ligament rupture**

When these stifle ligaments rupture, as a result of a severe sprain, the stifle, or knee joint, is destabilized and the dog becomes instantly and severely lame on that leg. This often occurs in middle-aged, overweight Westies. Surgical repair is usually necessary.

■ **Arthritis**

This, or degenerative joint disease other than

PET HEALTH INSURANCE

By choosing wisely in the beginning, and then ensuring that your dog is fit, the right weight, occupied both mentally and physically, protected against disease by vaccination, and fed correctly, you should be able to minimize any vets' bills. However, the unexpected may well happen. Accidents and injuries occur, and dogs can develop lifelong allergies or long-term illnesses, such as diabetes. Pet health insurance is available and is recommended by the vast majority of veterinarians for such unexpected eventualities. It is important to take out a policy that will suit you and your Westie, so it is wise to ask your veterinary surgeon in advance for his recommendation.

Perthe's disease, does occur in the West Highland White Terrier. It results in thickening of the joint capsule, formation of abnormal new bone around the edges of the joint and, sometimes, wearing of the joint cartilage. The joint becomes enlarged and painful, and has a reduced range of movement. It tends to occur in the older dog and usually affects the hips, stifles (knees) and elbows.

■ **Spondylitis**

This is arthritis of the spine. It is not common in the West Highland White Terrier.

FIRST AID, ACCIDENTS AND EMERGENCIES

First aid is the emergency care given to a dog suffering injury or illness of sudden onset.

AIMS OF FIRST AID

1 Keep the dog alive.
2 Prevent unnecessary suffering.
3 Prevent further injury.

RULES OF FIRST AID

1

Keep calm. If you panic you will be unable to help effectively.

2

Contact a vet as soon as possible. Advice given over the telephone may be life-saving.

3

Avoid injury to yourself. A distressed or injured animal may bite so use a muzzle if necessary (see muzzling, page 136).

4

Control haemorrhage. Excessive blood loss can lead to severe shock and death (see haemorrhage, page 129).

5

Maintain an airway. Failure to breathe or obtain adequate oxygen can lead to brain damage or loss of life within five minutes (see airway obstruction and artificial respiration, page 127).

COMMON ACCIDENTS AND EMERGENCIES

The following common accidents and emergencies all require first aid action. In an emergency, your priorities are to keep the dog alive and comfortable until he can be examined by a vet. In many cases, there is effective action that you can take immediately to help preserve your dog's health and life.

SHOCK AND ROAD ACCIDENTS *(side tab)*

SHOCK AND ROAD ACCIDENTS

SHOCK

This is a serious clinical syndrome which can cause death. Shock can follow road accidents, severe burns, electrocution, extremes of heat and cold, heart failure, poisoning, severe fluid loss, reactions to drugs, insect stings or snake bite.

SIGNS OF SHOCK

- Weakness or collapse
- Pale gums
- Cold extremities, e.g. feet and ears
- Weak pulse and rapid heart
- Rapid, shallow breathing

RECOMMENDED ACTION

1
Act immediately. Give cardiac massage (see page 128) and/or artificial respiration (see page 127) if necessary, after checking for a clear airway.

2
Keep the dog flat and warm. Control external haemorrhage (page 129).

3
Veterinary treatment is essential thereafter.

ROAD ACCIDENTS

Injuries resulting from a fast-moving vehicle colliding with an animal can be very serious. Road accidents may result in:

- Death
- Head injuries
- Spinal damage
- Internal haemorrhage, bruising and rupture of major organs, e.g. liver, spleen, kidneys
- Fractured ribs and lung damage, possibly resulting in haemothorax (blood in the chest cavity) or pneumothorax (air in the chest cavity)
- Fractured limbs with or without nerve damage
- External haemorrhage, wounds, tears and bruising

RECOMMENDED ACTION

1
Assess the situation and move the dog to a safe position. Use a blanket to transport him and keep him flat.

2
Check for signs of life: feel for a heart beat (see cardiac massage, page 128), and watch for the rise and fall of the chest wall to indicate breathing.

3
If the dog is breathing, treat as for shock (see above). If he is not breathing but there is a heart beat, give artificial respiration, after checking for airway obstruction. Consider the use of a muzzle (see muzzling, page 136).

4
Control external haemorrhage (see haemorrhage, page 129).

5
Keep the dog warm and flat at all times, and seek veterinary help.

AIRWAY OBSTRUCTION

■ **FOREIGN BODY IN THE THROAT**, e.g. a ball.

RECOMMENDED ACTION

1

This is an acute emergency. Do not try to pull out the object. Push it upwards and forwards from behind the throat so that it moves from its position in the throat, where it is obstructing the larynx, into the mouth.

2

The dog should now be able to breathe. Remove the object from his mouth.

■ **FOLLOWING A ROAD ACCIDENT**, or convulsion, blood, saliva or vomit in the throat may obstruct breathing.

RECOMMENDED ACTION

1

Pull the tongue forwards and clear any obstruction with your fingers.

2

Then, with the dog on his side, extend the head and neck forwards to maintain a clear airway.

DROWNING

RECOMMENDED ACTION

1 When out of the water, remove the collar and place the dog on his side with his head lower than his body.

2 With your hands, apply firm downward pressure at five-second intervals on the chest.

ARTIFICIAL RESPIRATION

This is the method for helping a dog which has a clear airway but cannot breathe.

RECOMMENDED ACTION

Use mouth-to-mouth resuscitation by cupping your hands over his nose and mouth and blowing into his nostrils every five seconds.

SHOCK AND ROAD ACCIDENTS

CARDIAC MASSAGE

This is required if your dog's heart fails.

RECOMMENDED ACTION

1

With the dog lying on his right side, feel for a heart beat with your fingers on the chest wall behind the dog's elbows on his left side.

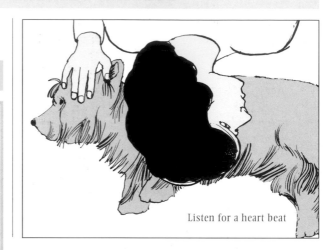

Listen for a heart beat

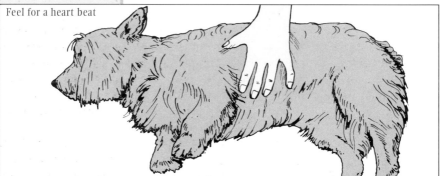

Feel for a heart beat

2

If you feel nothing, squeeze rhythmically with your palms, placing one hand on top of the other, as shown, at two-second intervals, pressing down hard.

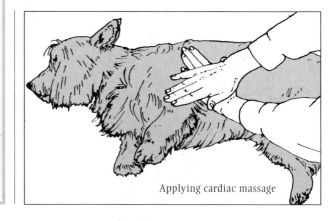

Applying cardiac massage

HAEMORRHAGE

Severe haemorrhage must be controlled, as it leads to a precipitous fall in blood pressure and the onset of shock. Haemorrhage is likely to result from deep surface wounds, or internal injuries, e.g. following a road accident.

■ **FOR SURFACE WOUNDS**

RECOMMENDED ACTION

Locate the bleeding point and apply pressure either with:
■ **Your thumb** or
■ **A pressure bandage** (preferred method) or
■ **A tourniquet**

1 **Pressure bandage**
Use a pad of gauze, cotton wool or cloth against the wound and tightly bandage around it. In the

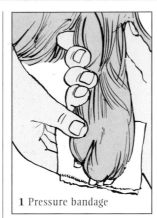

1 Pressure bandage

absence of a proper dressing, use a clean handkerchief or scarf.

2 If the bleeding continues, apply another dressing on top of the first.

1 **Tourniquet** (on limbs and tail)
Tie a narrow piece of cloth, a neck tie or dog lead tightly

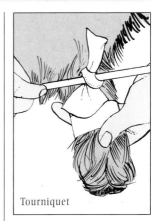

Tourniquet

around the limb, nearer to the body than the wound itself.

2 Using a pencil or stick within the knot, twist until it becomes tight enough to stop the blood flow.

3 **Important**: you must seek veterinary assistance as soon as possible.

Note: Tourniquets should be applied for no longer than fifteen minutes at a time, or tissue death may result.

■ **FOR INTERNAL BLEEDING**

RECOMMENDED ACTION

1 You should keep the animal quiet and warm, and minimize any movement.

2 **Important**: you must seek veterinary assistance as soon as possible.

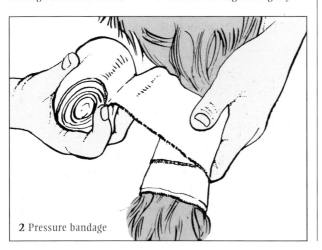

2 Pressure bandage

SHOCK AND ROAD ACCIDENTS

WOUNDS

These may result from road accidents, dog fights, sharp stones or glass, etc. Deep wounds may cause serious bleeding, bone or nerve damage.

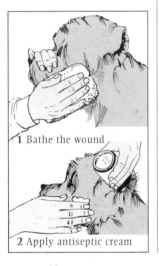

1 Bathe the wound

2 Apply antiseptic cream

RECOMMENDED ACTION

1

Deal with external bleeding (see haemorrhage, page 129) and keep the dog quiet before seeking veterinary attention.

2

Cut feet or pads should be bandaged to prevent further blood loss.

3

Minor cuts, abrasions and bruising should be bathed with warm salt solution (one

5ml teaspoonful per 550ml (1 pint) of water). They should be protected from further injury or contamination. Apply some antiseptic cream, if necessary.

4

If in doubt, ask your vet to check in case the wound needs suturing or antibiotic therapy, particularly if caused by fighting. Even minor cuts and punctures can be complicated by the presence of a foreign body.

FRACTURES

Broken bones often result from road accidents, especially in the legs. Be careful when lifting and transporting the affected dog.

■ **LEG FRACTURES**

RECOMMENDED ACTION

1 Broken lower leg bones can sometimes be straightened gently, bandaged and then taped or tied with string to a make-

shift splint, e.g. a piece of wood or rolled-up newspaper or cardboard.

2 Otherwise, support the leg to prevent any movement. Take the dog to the vet immediately.

■ **OTHER FRACTURES**
These may be more difficult to diagnose. If you suspect a fracture, transport your dog very gently with great care, and get him to the vet.

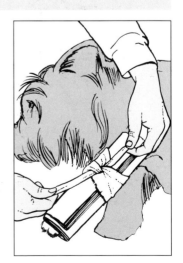

OTHER ACCIDENTS AND EMERGENCIES

COLLAPSE

This may be accompanied by loss of consciousness, but not in every case.

POSSIBLE CAUSES

■ Head trauma, e.g. following a road accident
■ Heart failure
■ Stroke
■ Hyperthermia (heat-stroke)
■ Hypothermia (cold)
■ Hypocalcaemia (low calcium)
■ Shock

■ Spinal fractures
■ Asphyxia (interference with breathing)
■ Electrocution
■ Poisoning

Note: you should refer to the relevant section for further details of these problems.

RECOMMENDED ACTION

1 The collapsed animal must be moved with care to avoid further damage.

2 Gently slide him on his side onto a blanket or coat.

3 Check he is breathing, and then keep him quiet and warm until you obtain professional help.

4 If he is not breathing, administer artificial respiration immediately, after checking for a clear airway (see page 127).

CONVULSIONS (FITS OR SEIZURES)

These are very alarming to dog owners. Uncontrolled spasms, 'paddling' of legs, loss of consciousness, sometimes salivation and involuntary urination or defecation occur. Most convulsions only last a few minutes, but the dog is often confused and dazed afterwards.

POSSIBLE CAUSES
- Poisoning
- Head injuries
- Brain tumours
- Liver and kidney disease
- Meningitis
- Epilepsy
- Low blood glucose, e.g. in diabetes, or low blood calcium, e.g. in eclampsia

RECOMMENDED ACTION

1 Unless he is in a dangerous situation, do not attempt to hold the dog, but protect him from damaging himself.

2 Do not give him anything by mouth.

3 Try to keep him quiet, cool and in a darkened room until he sees the vet.

4 If you have to move him, cover him with a blanket first.

HEART FAILURE

This is not as common in dogs as in humans. Affected dogs faint, usually during exercise, and lose consciousness. The mucous membranes appear pale or slightly blue.

RECOMMENDED ACTION

1 Cover the dog in a blanket, and lie him on his side.

2 Massage his chest behind the elbows (see cardiac massage, page 128).

3 When he recovers, take him straight to the vet.

1 An affected dog should be covered with a blanket and laid on his side.
2 Apply cardiac massage, pressing down firmly at two-second intervals.

HEAT-STROKE

This occurs in hot weather, especially when dogs have been left in cars with insufficient ventilation. Affected animals are extremely distressed, panting and possibly collapsed. They can die rapidly. A heat-stroke case should be treated as an acute emergency.

RECOMMENDED ACTION

1 Place the dog in a cold bath or run cold water over his body until his temperature is in the normal range.

2 Offer water with added salt (one 5ml teaspoonful per half litre (18 fl oz) water).

3 Treatment for shock may be necessary (see page 126).

ELECTROCUTION

This is most likely to occur in a bored puppy who chews through a cable. Electrocution may kill him outright or lead to delayed shock.

■ **DO NOT TOUCH HIM BEFORE YOU SWITCH OFF THE ELECTRICITY SOURCE.**

RECOMMENDED ACTION

1 If he is not breathing, begin artificial respiration immediately (see page 127) and keep him warm.

2 Contact your vet; if he survives he will need treatment for shock (see page 126).

BURNS AND SCALDS

POSSIBLE CAUSES
■ Spilled hot drinks, boiling water or fat
■ Friction, chemical and electrical burns

RECOMMENDED ACTION

1 Immediately apply running cold water and, thereafter, cold compresses, ice packs or packets of frozen peas to the affected area.

2 Veterinary attention is essential in most cases.

SNAKE BITE

This is due to the adder in Great Britain. Signs are pain accompanied by a soft swelling around two puncture wounds, usually on either the head, neck or limbs. Trembling, collapse, shock and even death can ensue.

RECOMMENDED ACTION

1 Do not let the dog walk; carry him to the car.

2 Keep him warm, and take him immediately to the vet.

OTHER ACCIDENTS AND EMERGENCIES

FOREIGN BODIES

■ **IN THE MOUTH**
Sticks or bones wedged between the teeth cause frantic pawing at the mouth and salivation.

RECOMMENDED ACTION

Remove the foreign body with your fingers or pliers, using a wooden block placed between the dog's canine teeth if possible to aid the safety of this procedure. Some objects have to be removed under general anaesthesia.
Note: a ball in the throat is dealt with in airway obstruction (see page 127), and is a critical emergency.

■ **FISH HOOKS**
Never try to pull these out, wherever they are.

RECOMMENDED ACTION

Push the fish hook through the skin, cut the end with pliers and then push the barbed end through.

■ **IN THE EAR – GRASS SEEDS**
These are the little spiky seeds of the wild barley, and are a real nuisance to dogs, particularly hairy ones like Westies. If one finds its way into an ear, it can produce sudden severe distress and

violent head shaking.

RECOMMENDED ACTION

If you can see the seed, gently but firmly pull it out with tweezers, and check it is intact. If you cannot see it, or feel you may have left some in, call the vet immediately.

■ **IN THE FOOT**
Glass, thorns or splinters can penetrate the pads or soft skin, causing pain, and infection if neglected.

RECOMMENDED ACTION

Soak the foot in warm salt water and then use a sharp sterilized needle or pair of tweezers to extract the foreign body. If this is not possible, take your dog to the vet who will remove it under local or general anaesthetic if necessary.

NOSE BLEEDS

These may be caused by trauma or violent sneezing, but are also related in some cases to ulceration of the lining of the nasal cavity.

RECOMMENDED ACTION

1 Keep the dog quiet and use ice packs on the bridge of the nose.

2 Contact your vet if the bleeding persists.

EYEBALL PROLAPSE

Not a common problem in West Highland White Terriers, but may arise from head trauma, e.g. following a dog fight. The eye is forced out of its socket and sight is lost unless it is replaced within fifteen minutes.

RECOMMENDED ACTION

1 Speed is essential. One person should pull the eyelids apart while the other gently presses the eyeball back into its socket, using moist sterile gauze or cloth.

2 If this is impossible, cover the eye with moist sterile gauze and take him to your vet immediately.

GASTRIC DILATION

This is an emergency and cannot be treated at home. The stomach distends with gas and froth which the dog cannot easily eliminate. In some cases, the stomach then rotates and a torsion occurs, so the gases cannot escape at all and the stomach rapidly fills the abdomen. This causes pain, respiratory distress and circulatory failure. Life-threatening shock follows. It is a very rare condition in the Westie.

PREVENTIVE ACTION

1 Avoid the problem by not exercising your dog vigorously for two hours after a full meal.

2 If your dog is becoming bloated and has difficulty breathing, he is unlikely to survive unless he has veterinary attention within half an hour of the onset of symptoms, so get him to the vet immediately.

POISONING

Dogs can be poisoned by pesticides, herbicides, poisonous plants, paints, antifreeze or an overdose of drugs (animal or human).

■ If poisoning is suspected, first try to determine the agent involved, and find out if it is corrosive or not. This may be indicated on the container, but may also be evident from the blistering of the lips, gums and tongue, and increased salivation.

RECOMMENDED ACTION

■ **CORROSIVE POISONS**

1 Wash the inside of the dog's mouth.

2 Give him milk and bread to protect the gut against the effects of the corrosive.

3 Seek veterinary help.

■ **OTHER POISONS**

1 If the dog is conscious, make him vomit within half an hour of taking the poison.

2 A crystal of washing soda or a few 15ml tablespoonfuls of strong salt solution can be given carefully by mouth.

3 Retain a sample of vomit to aid identification of the poison, or take the poison container with you to show the vet. There may be an antidote, and any information can help in treatment.

STINGS

Bee and wasp stings often occur around the head, front limbs or mouth. The dog usually shows sudden pain and paws at, or licks, the stung area. A soft, painful swelling appears; sometimes the dog seems unwell or lethargic. Stings in the mouth and throat can be distressing and dangerous.

RECOMMENDED ACTION

1 Withdraw the sting (bees).

2 Then you can bathe the area in:

■ Vinegar for wasps

■ Bicarbonate for bees

3 An antihistamine injection may be needed.

OTHER ACCIDENTS AND EMERGENCIES

BREEDING

ECLAMPSIA

This is an emergency which may occur when your Westie bitch is suckling puppies, usually when the pups are about three weeks old. Consult your vet immediately.

PARAPHIMOSIS

(See page 120)
This problem may occur after mating, in your male Westie. His engorged penis is unable to retract into the sheath.

MUZZLING

This will allow a nervous, distressed or injured dog to be examined safely, without the risk of being bitten. A tape or bandage is secured around the muzzle as illustrated. However, a muzzle should not be applied in the following circumstances:

■ Airway obstruction
■ Loss of consciousness
■ Compromised breathing or severe chest injury

1 Tie a knot in the bandage.

2 Wrap around the dog's muzzle with the knot under the lower jaw.
3 Tie firmly behind the dog's head.

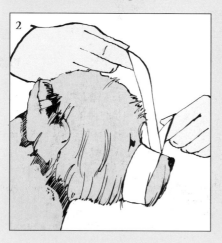

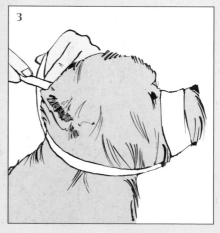

GLOSSARY

Angulation
The angles created by bones meeting at a joint.
Breed standard
The description laid down by the Kennel Club of the perfect breed specimen.
Brood bitch
A female dog which is used for breeding.
Carpals
These are the wrist bones.
Croup
This is the dog's rump: the front of the pelvis to the start of the tail.
Dam
The mother of puppies.
Dew claw
A fifth toe above the ground on the inside of the legs.

Elbow
The joint at the top of the forearm below the upper arm.
Flank
The area between the last rib and hip on the side of the body.
Furnishings
The long hair on the head, legs, thighs, back of buttocks or tail.
Gait
How a dog moves at different speeds.
Guard hairs
Long hairs that grow through the undercoat.
Muzzle
The foreface, or front of the head.
Occiput
The back upper part of the skull.

Oestrus
The periods when a bitch is 'on heat' or 'in season' and responsive to mating.
Pastern
Between the wrist (carpus) and the digits of the forelegs.
Scissor bite
Strong jaws with upper teeth overlapping lower ones.
Stifle
The hind leg joint, or 'knee'.
Undercoat
A dense, short coat hidden below the top-coat.
Whelping
The act of giving birth.
Whelps
Puppies that have not been weaned.
Whiskers
Long hairs on the jaw and muzzle.

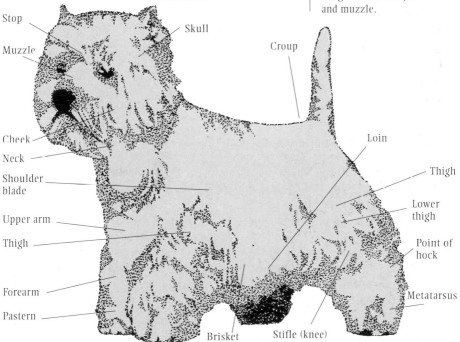

Stop
Muzzle
Skull
Croup
Cheek
Neck
Shoulder blade
Upper arm
Thigh
Forearm
Pastern
Loin
Thigh
Lower thigh
Point of hock
Metatarsus
Brisket
Stifle (knee)

INDEX

FURTHER READING (PERIODICALS)

Dogs Monthly
R T C Associates, Ascot House
High Street, Ascot
Berks SL5 7JG

Dogs Today
Pet Subjects Ltd
Pankhurst Farm, Bagshot Road

West End, Nr Woking
Surrey GU24 9QR

Dog Training Weekly
4/5 Feidr Castell Business
Park,
Fishguard
Dyfed SA65 9BB

Dog World
9 Tufton Street
Ashford, Kent TN23 1QN

Our Dogs
5 Oxford Road,
Station Approach
Manchester M60 1SX

Animal Aunts
Smugglers
Green Lane
Rogate
Petersfield
Hampshire
GU31 5DA
(Home sitters, holidays)

**Association of Pet
Behaviour Counsellors**
PO Box 46
Worcester
WR8 9YS

**British Veterinary
Association**
7 Mansfield Street
London
W1G 9NQ

**Dog Breeders Insurance
Co Ltd**
9 St Stephens Court
St Stephens Road
Bournemouth
BH2 6LG
(Books of cover notes for
dog breeders)

**Featherbed
Country Club**
High Wycombe
Bucks
HP15 6XP
(Luxury dog accommodation)

**Guide Dogs for the
Blind Association**
Burghfield Common
Reading
RG7 3YG

Hearing Dogs for the Deaf
The Training Centre
London Road
Lewknor
Oxon OX9 5RY

The Kennel Club
1-5 Clarges Street
Piccadilly
London W1Y 8AB
(Breed Standards, Breed Club
and Field Trial contact
addresses, registration forms,
Good Citizen training scheme)

**National Canine
Defence League**
17 Wakeley Street
London
EC1V 7RQ

**Pets As Therapy
(PAT Dogs)**
10a Welldon Cres
Harrow
Middlesex
HA1 1QT
(Information: how friendly
dogs can join the hospital
visiting scheme)

**PRO Dogs
National Charity**
4 New Road
Ditton
Kent
ME20 6AD
(Information: Better British
Breeders, worming certificates
to provide with puppies, how
to cope with grief on the loss
of a loved dog etc.)

**Royal Society for the
Prevention of Cruelty
to Animals**
RSPCA Headquarters
Wilberforce Way
Southwater
Horsham
West Sussex
RH12 1HG

**WitsEnd School
for Dogs**
Scampers Petcare Superstore
Northfield Crossroads
Soham
Ely
Cambs CB7 5UF
Tel: 01353 727111